C000261966

BLANDFORD

THROUGH TIME

Sylvia Hixson Andrews
& Sara Loch

AMBERLEY PUBLISHING

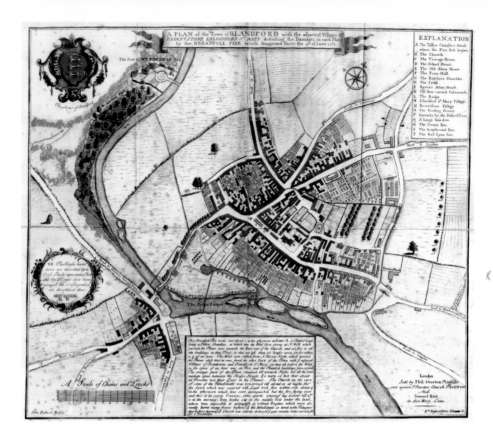

This text comes from an engraved paving stone in front of the Corn Exchange:

Recipe for regeneration
take one careless
tallow chandler
and two ingenious Bastards

First published 2010

Amberley Publishing Plc
Cirencester Road, Chalford,
Stroud, Gloucestershire, GL6 8PE

www.amberley-books.com

The right of Sylvia Hixson Andrews & Sara Loch to
be identified as the Authors of this work has been
asserted in accordance with the Copyrights, Designs
and Patents Act 1988.

ISBN 978 1 84868 538 3

British Library Cataloguing in Publication Data.
A catalogue record for this book is available from
the British Library.

Typeset in 9.5pt on 12pt Celeste.
Typesetting by Amberley Publishing.
Printed in the UK.

Introduction

If you google Blandford Forum, you will find phrases such as "a unique Georgian town" and "the best preserved Georgian architecture in England". One of the pleasures of writing this book has been the delightful experience of ransacking the photographic archives; finding the existing views today in order to photograph them; and being increasingly amazed by how much of the Georgian architecture and views have remained intact.

The name Blandford Forum comes from the fact that the market town grew at the site of a ford across the River Stour, Blaen-y-ford, "the place by the ford". The town became Blandford and later Blandford Forum when Forum was added to distinguish the market Blandford from Blandford Langton Long, Blandford St Mary and Blandford Brian (now Bryanston).

The town was originally, and continues to be, a small market town. It shows the effects of local industries such as the Hall and Woodhouse Brewery and the Army presence in Blandford Camp on the outskirts of town.

The one factor that has done most to shape the look of Blandford Forum however was the fire of 1731. The fire started at 2pm in what is now the Kings Arms Hotel but was then a tallow chandlery, and by 8pm almost the entire town was gone. Many people sheltered in the church, but at 2am that roof caught fire. With no ladders, as they had all been burnt, it was left to burn and the whole building collapsed, destroying generations of records of marriages, births, deaths and property holdings but thankfully none of those taking refuge there.

The winners in this drama are definitely John and William Bastard, from a family of architects, surveyors and builders, who were responsible for much of the rebuilding work. The town itself also benefited in that the restoration building done by these talented brothers has given rise to the lovely, quirky but contemporaneous style seen throughout the centre of town. The various planning authorities must also be commended for the way in which so much of this has been conserved and protected. For while the ground level shop windows often have been modernised, from the first floors to the rooftops, Blandford Forum remains a "Unique Georgian Town".

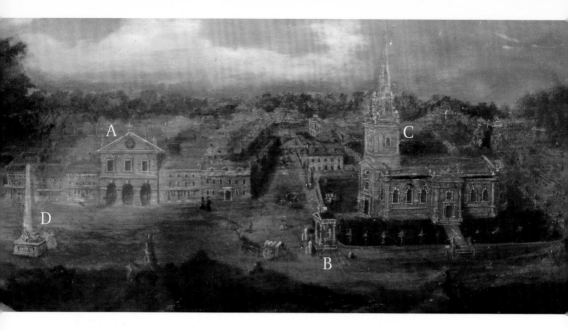

Blandford Forum

This is a very early image of Blandford Forum, painted on board by an unknown artist. The image, painted after the 1731 fire, is an imaginary one. The Corn Exchange (A) was built in 1740 and the Water Pump (B) in 1760. (C) shows the church with a tower, but, in reality, a cupola was placed on the structure as a temporary measure until funds were found for the tower, which remains to this day. (D) is a Market Cross replacing the one that had been destroyed but was, in fact, never built.

The painting is the property of Dorset County Council and hangs in the Blandford Forum Library. It is believed to have been painted to show the vision that John and William Bastard had for the rebuilding of the town.

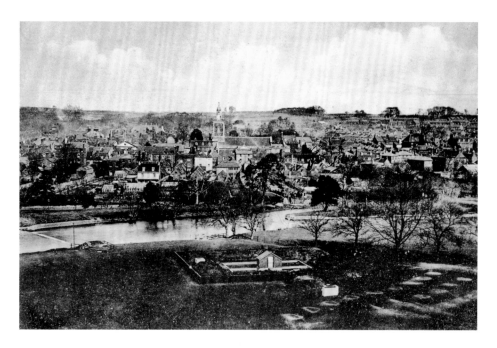

Aerial View

This early photograph was taken from a great height, the top of the Hall and Woodhouse Brewery, situated on the other side of the River Stour in Blandford St. Mary. The brewery has had a succession of owners beginning with William Clapcott in the 1770s but now is run by the Woodhouse family. To duplicate this photograph, we requested and received the assistance of Adrian Oliver, a talented photographer who is in the employ of the brewery. The blanked out areas are there for reasons of privacy, however the amazing thing is how little the view of Blandford Forum has changed over the years.

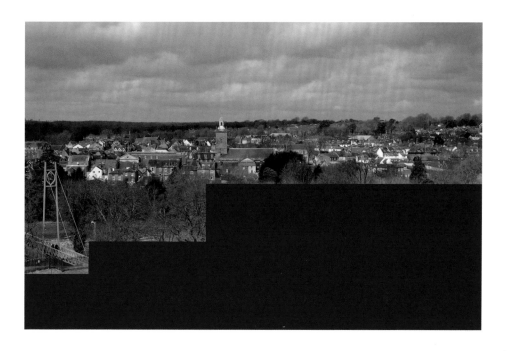

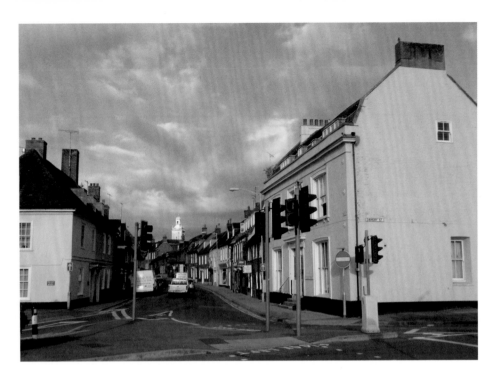

East Street

These views from the end of Wimborne Road down the beginning of East Street are strikingly alike. The lower photograph, taken in the 1920s, shows the view of Blandford when standing in front of the Somerset and Dorset railway bridge. When taking the current view there is no bridge to stand in front of, as it, as part of the removal of the railway and Blandford Station, was blown up.

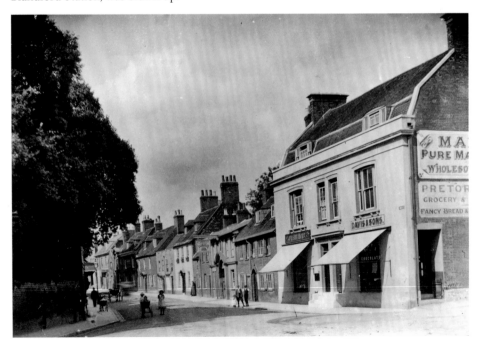

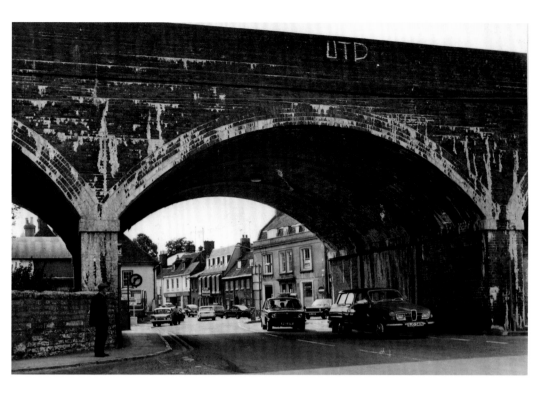

Railway Bridge

The top photograph shows the railway bridge that spanned Wimborne Road as part of the Somerset and Dorset Railway and the bottom one its demolition on 25 July 1978. This demolition caused a lot of interest in the community; and a lottery was held to select the person who pushed the detonator button.

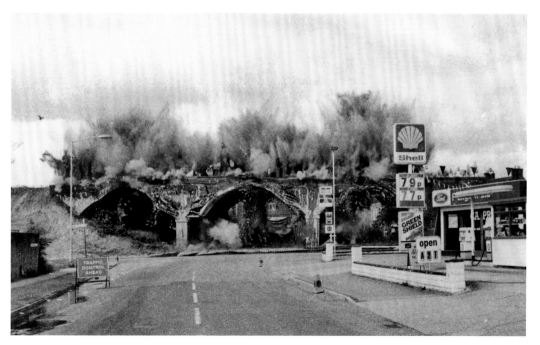

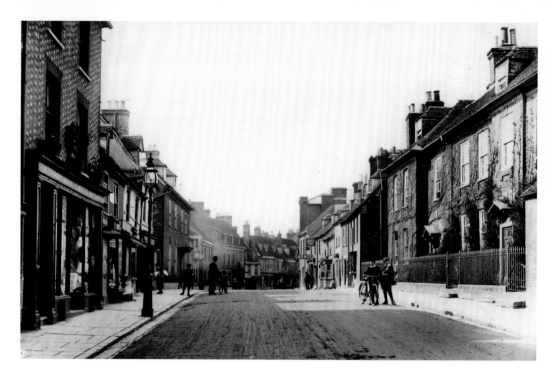

East Street

These photographs continue down East Street towards the centre of Blandford. Some of the large houses on the right of street have been replaced by businesses. A school was located on the left side of the street in Victorian times, but the building was destroyed and replaced by the Palace Cinema, see page 71. The building became a supermarket and is now a clothing store.

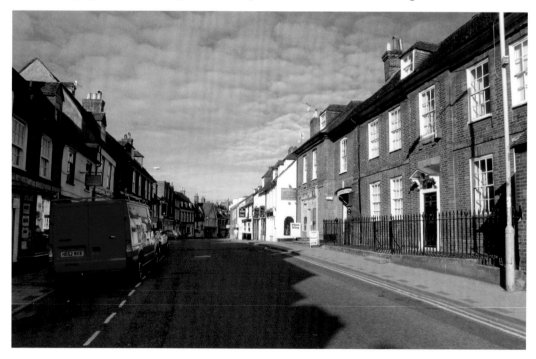

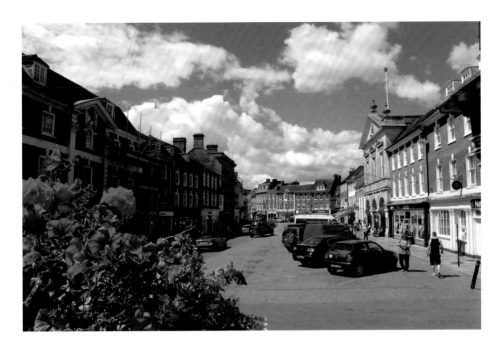

Market Place

Looking at the north side of the Market Place the grand façade of the Town Hall and Shambles, leading through to the Corn Exchange, are on the right. The occupants of the street level storefronts may have changed, but from the first floor up, most buildings retain their Georgian architecture. Consequently the architecture of the Market Place today is still similar to that in 1900 when the bottom photograph was taken. Then the road was two-way, but now it is one-way with parking.

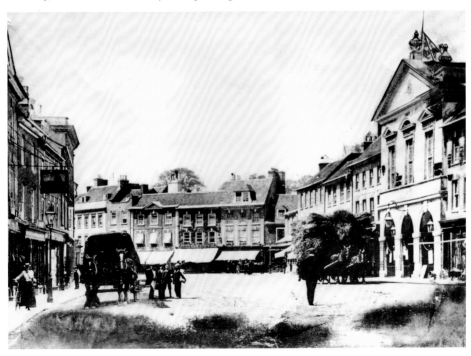

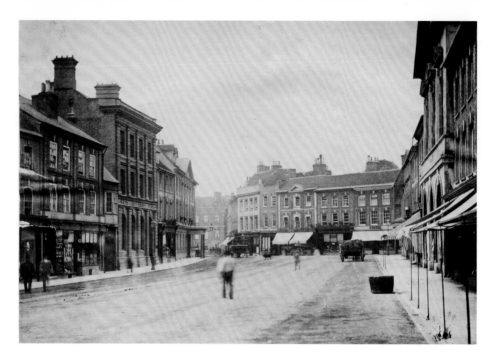

Market Place

Looking at the south side of the Market Place, the entrance to West Street, the road that leads to Dorchester can be seen at the far end. Before the fire there was a market cross at the west end. Blandford had three major inns that were used by the London to Exeter Coaches. Two, the Red Lion, now a private residence and business, and the Greyhound, a solicitor and a pub, were in the Market Place. The third, the Crown, still a hotel, can be glimpsed on the bend in West Street.

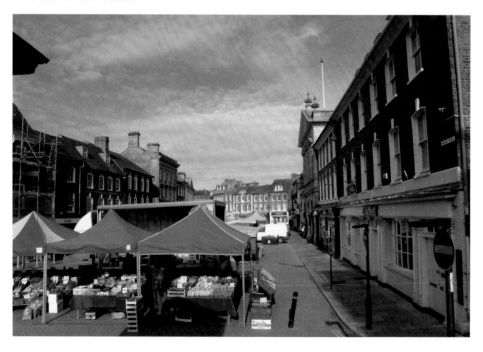

Coming into Town from the West End

Coming into Blandford from Dorchester, the county town, you pass through Blandford St Mary. Just before crossing the River Stour, the boundary between the town and parish, you pass the entrance to Bryanston where these photographs were taken. It is now a school, but previously the estate was in the possession of the Portman family. The church cupola can been seen in both pictures, even if mostly obscured by trees in the modern one.

West Street

Once over the bridge you enter West Street with the Crown Hotel straight ahead. This lovely view has caused some controversy in recent times with plans for both building and car parking being proposed. However the bucolic beauty of this entrance into Blandford has been deemed worthy of preservation, for now.

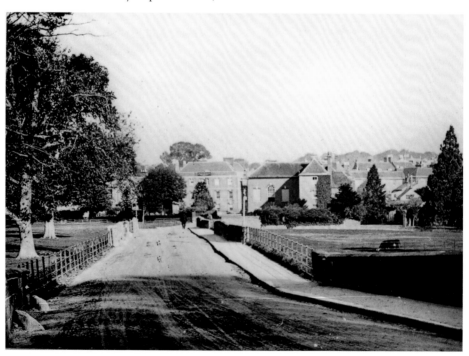

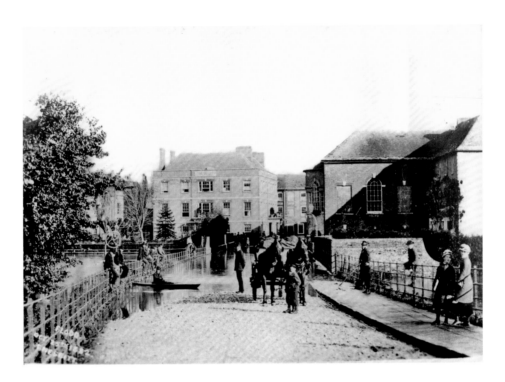

West Street

These photographs are taken further down West Street. The top one was taken after one of the floods that were common occurrences prior to the construction of the town's flood defences in 1995. The Assembly Rooms on the right have undergone a transformation recently and now are grander in appearance than the original. They have had several incarnations including a garage (see inset), a Chinese restaurant and flats.

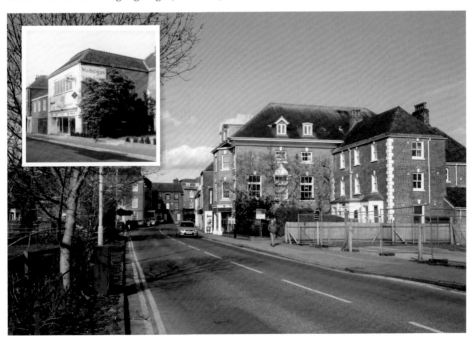

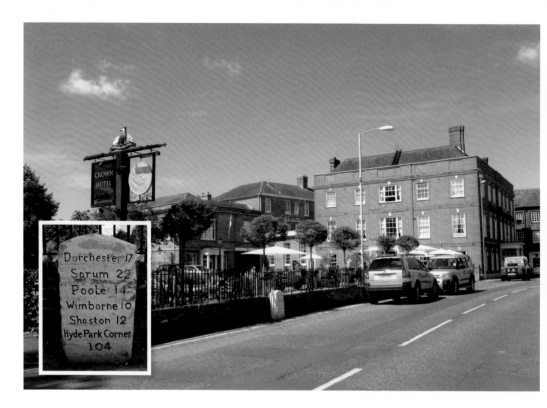

Crown Hotel

The Crown Hotel sits at a bend in West Street before it reaches the Market Place. The volume of traffic using this road does not allow for children playing now! The inset shows a close-up of the milestone that can be seen in both pictures, which clearly allows for pinpoint accuracy in placing Blandford on the map.

Salisbury Street

Leaving the Market Place and running north is Salisbury Street. This was the road out of Blandford to Salisbury and on to London. The architecture has not changed much, neither has the practice of delivery men parking at the roadside. What has changed is the mode of transport and delivery.

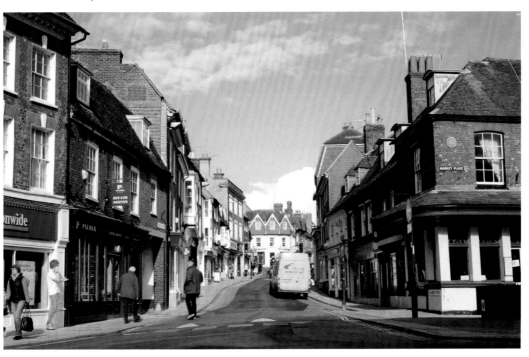

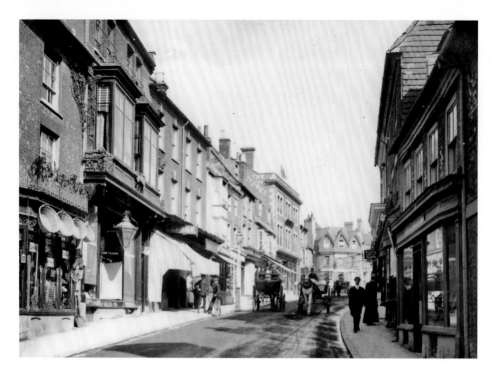

Salisbury Street

Still in Salisbury Street it should be noted that the houses on the left side were originally in the parish of Pimperne and so not technically in Blandford. Those owning them could not hold a political position in Blandford. However a by-law was passed allowing anyone whose house overhung the footpath to be eligible for office and if you look closely you will see that many of the houses on the west side (the left as we are looking at it) have first floor overhangs.

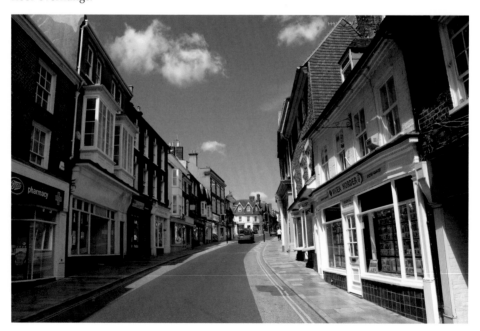

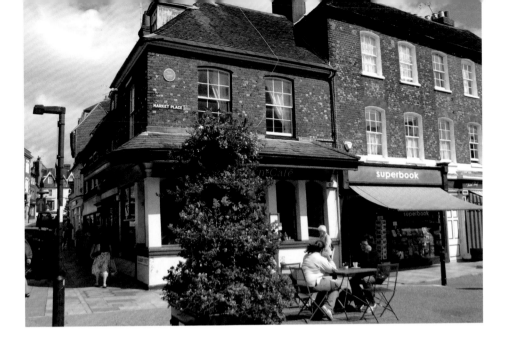

Durden's Corner

The north-west corner of the Market Place is known locally as Durden's Corner. It was owned by the Durden family as far back as 1791. As well as being a shop, it has also been home to Henry Durden's archaeological collection, which consisted of thousands of objects primarily collected from Hod Hill. This collection was sold to the British Museum in the 1890s following his death for the then fantastic sum of £876. It is considered by experts to be the largest and most significant Romano British collection in England. The building is now owned by the Hall and Woodhouse brewery and is the Half Crown Café (a reference to the much larger Crown Hotel also owned by the brewery). The old photograph was taken in 1895.

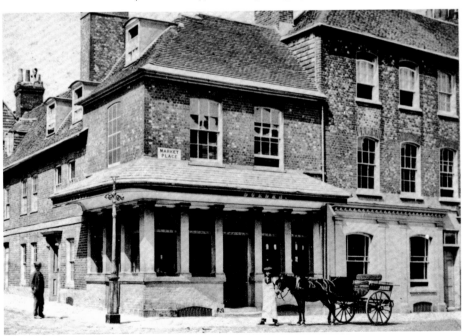

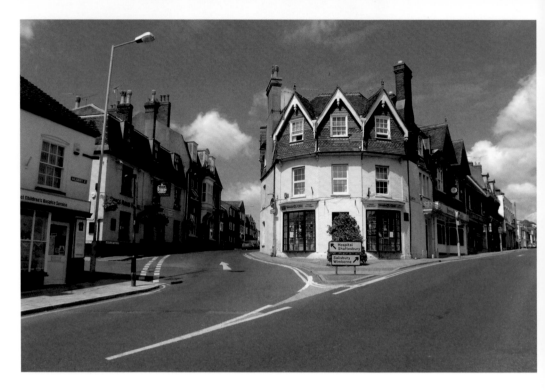

Salisbury Street

Half way up Salisbury Street there is a fork with Whitecliff Mill Street running off to the left. In the middle of this division sits the building which housed the *Blandford Express* Newspaper between 1869 and 1894. This shows the building covered by heavy snow in 1891. Today the building contains flats and a hairdressing salon.

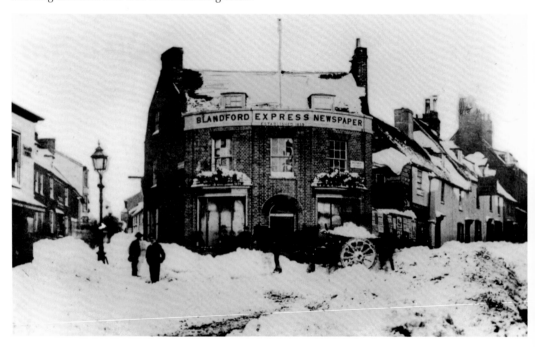

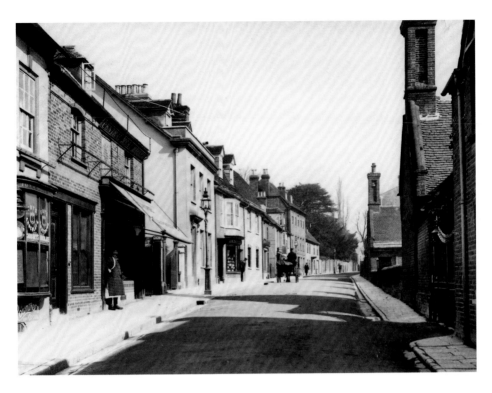

Salisbury Street

Continuing up Salisbury Street, the Ryves Almshouses are located on the right. This building is one of the few which survived the 1731 fire. They were set up in 1682, according to the stone above the entrance, with money left in the will of George Ryves of Ranston. In the foreground to the right is one of the entrances into Field Oaks.

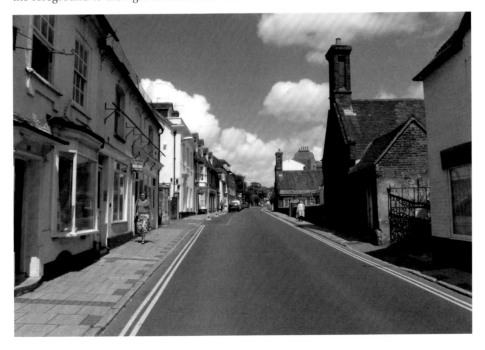

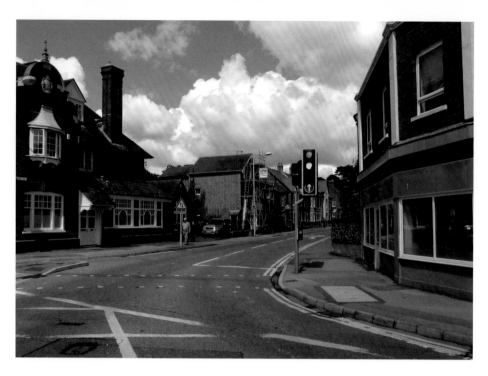

Badger Crossroads

At the top of Salisbury Street, where it becomes Salisbury Road, is this junction known as Badger Crossroads. The house in the foreground on the left is Badger House, so called as it was the Badger Inn established in 1899. It now houses a firm of accountants. The building on the right in the old photograph was Mr Dudderidge's Nursery.

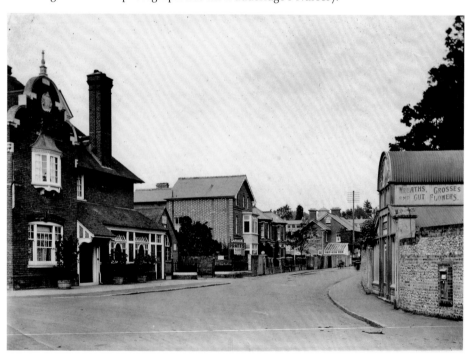

Salisbury Road

Further up Salisbury Road you can see in the distance on the left, the Union House. Hutchins records that the Workhouse of Industry stood at the end of East Street and in 1859 a new Union House was built to the left of Salisbury Road overlooking the town. The field in front of it was called The Fairfield and has been replaced by housing that includes a Fairfield Road.

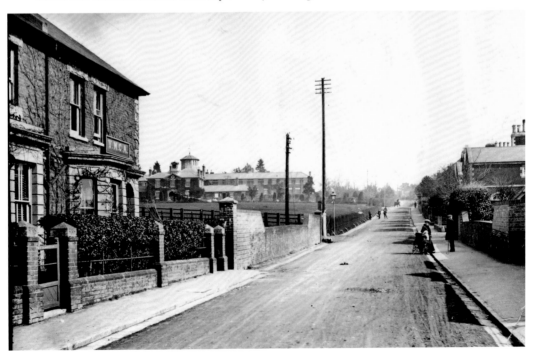

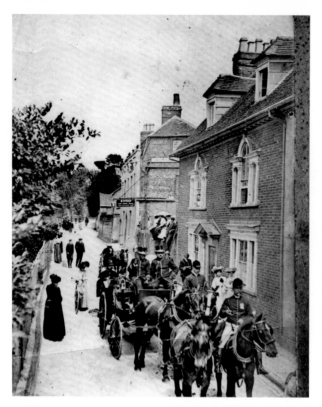

Whitecliff Mill Street
This view is of Whitecliff Mill Street as it climbs from the Marketplace and towards the outskirts of town. The trees on the left side of the street are gone. Further up the road on the left and right, many fine early Victorian private homes still stand. The two cream coloured Georgian buildings now provide bookends for Whitecliff House, a nursing home.

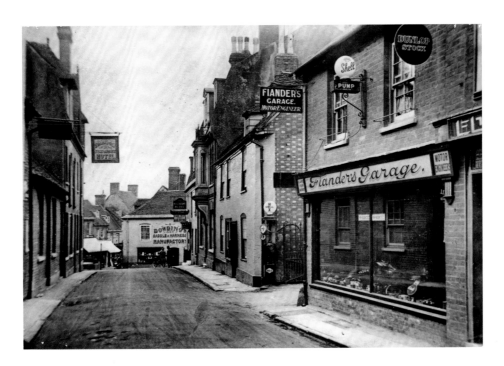

Whitecliff Mill Street

This view of the bottom of Whitecliff Mill Street looking towards the Market Place is much changed with the demolition of several buildings to make way for Ryan Court, just visible on the right of the modern photograph. On the right, just before the white house in the distance, is the King's Arms Hotel (shown in the inset), the site of the tallow chandler's shop where the fire of 1731 started.

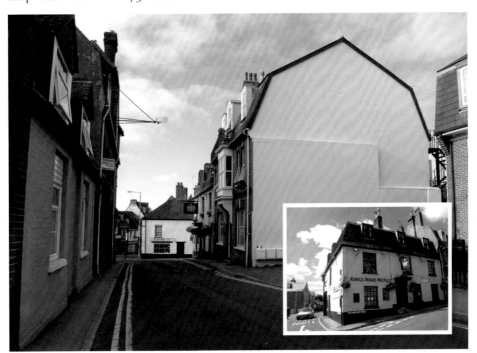

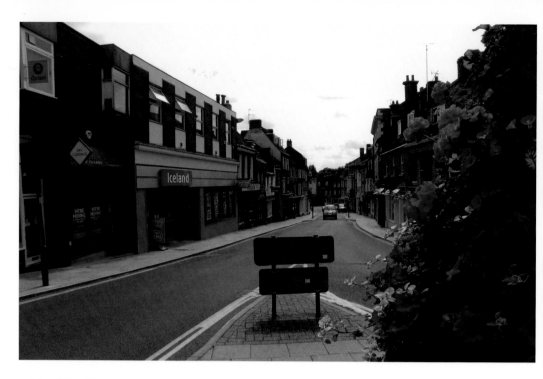

Whitecliff Mill Street

This view is taken from the point that Whitecliff Mill Street and Salisbury Street join. In an Act of Parliament passed in 1732 regulating the re-building of Blandford, this part of Salisbury Street had a specific mention. A notorious vehicular bottleneck was cleared by widening 'Part of Salisbury Street by taking the Ground whereon three Houses stood'. The bottom picture, taken in 1964, shows the street before Woolworth's and later Iceland were built.

Bryanston Street

The top photograph is a picture of the Brewery of J. L. Marsh that was located in Bryanston Street. It was replaced in the 1980s by Ryan Court as seen in the bottom photograph. However note the attempt to recreate the brewery's overhanging delivery bay.

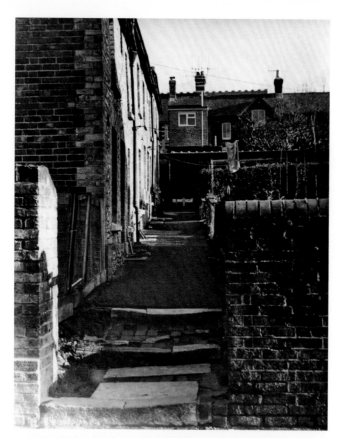

Alleyways
Blandford has many little alleyways, or snickets. Although the top one no longer exists there are still many running off the larger thoroughfares. The Georgian passage shown in the bottom photograph retains many of its original characteristics including its cobblestones.

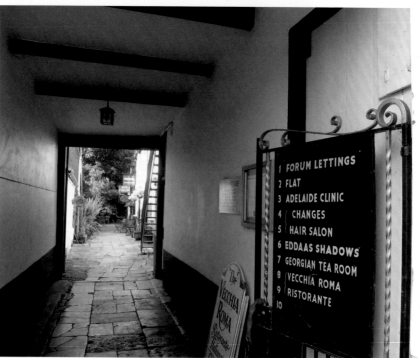

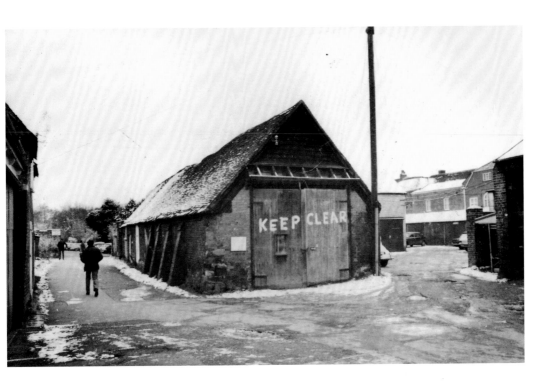

Greyhound Yard

Through an arch next to what is now Greyhound House is the site of the stables and coaching yard for the old Greyhound Inn. What is not shown in the older view is the Greyhound pub, on the left that is still operating today. The Morrison's building in Greyhound Yard is a poor replacement for the original barn that filled the site.

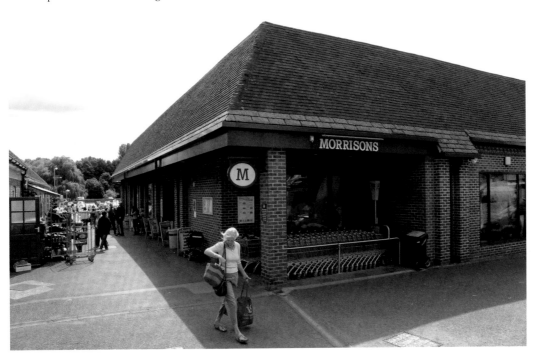

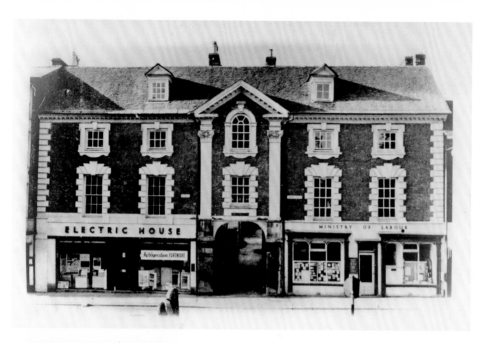

Bastard House

These pictures show the spectacular house that was built by the architects, surveyors and builders of Blandford Forum, John and William Bastard, for their own use. The house fronts onto East Street and is very grand. It is likely that the brothers used the detailing on the house and in the interior to showcase their abilities. The inset shows some of the wonderful plasterwork to be found inside in a room possibly used as a salesroom.

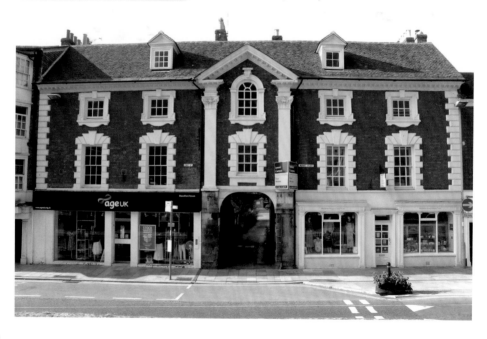

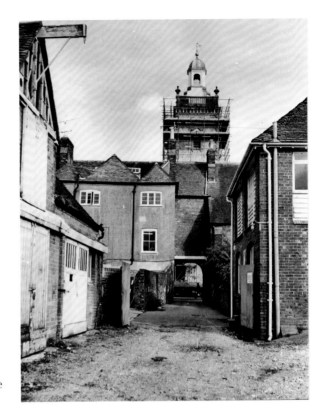

Beres Yard

Through the arch that runs through the middle of East Street beside the house that the Bastard brothers built and lived in, is Beres Yard. These photographs are taken looking back towards East Street and the parish church. The Blandford Town Museum now occupies the remains of a barn or stable on the left, which could have been used by the Bastard family.

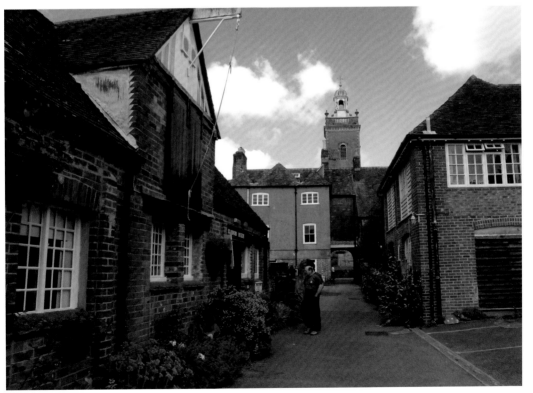

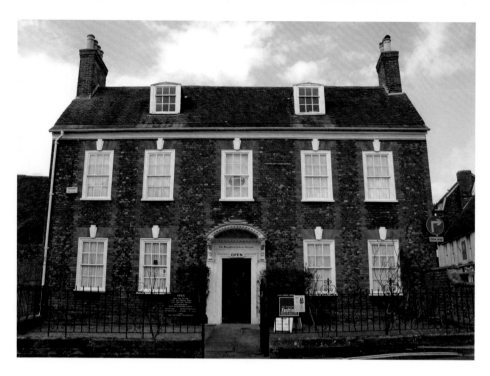

Lime Tree House

Lime Tree House, situated at the top of Church Lane, is thought to have been built by the Bastard brothers in about 1740 for their sisters. It now houses the Fashion Museum, based on Mrs Penny's Cavalcade of Costume, which not only has an interesting permanent collection but puts on exhibitions such as one on the Little Black Dress.

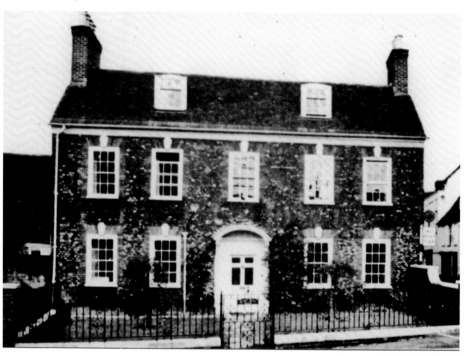

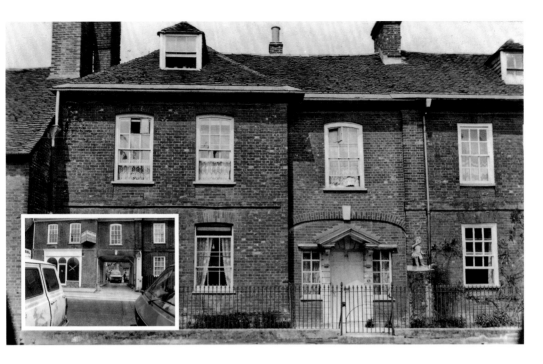

Munster House

Munster House, in East Street, was a matching pair with its neighbour, Lyston House. However, in 1985, an alleyway was knocked through and a small group of retail/business outlets, called Tabernacle Walk, was erected behind. The inset shows the work in progress.

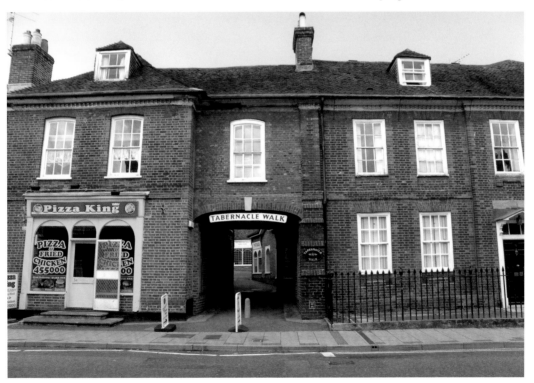

Cedars House
What was Cedars House located on one side of Badger Crossroads is now replaced by a modern collection of flats called The Cedars. So the name at least has been preserved.

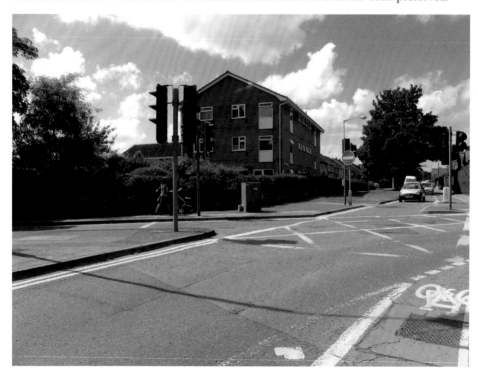

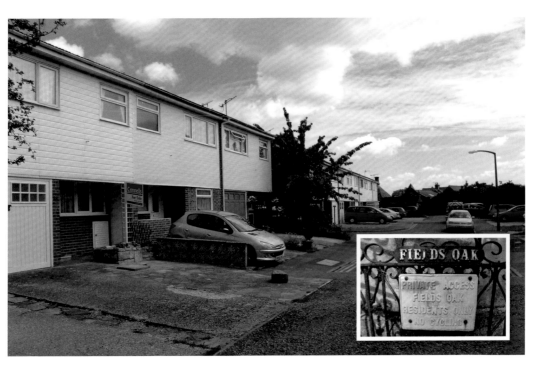

Fields Oak

The site of this very elegant villa, Fields Oak, built by Thomas Hodges Bennett in 1856 is a cul-de-sac of modern housing built in 1970. The pedestrian entrance from Salisbury Street has an old metalwork gate, possibly from the original house. The inset shows the sign it sports.

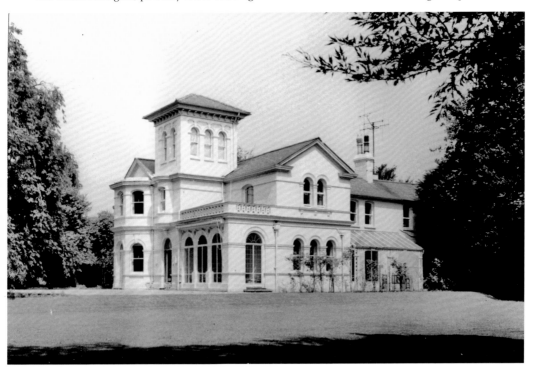

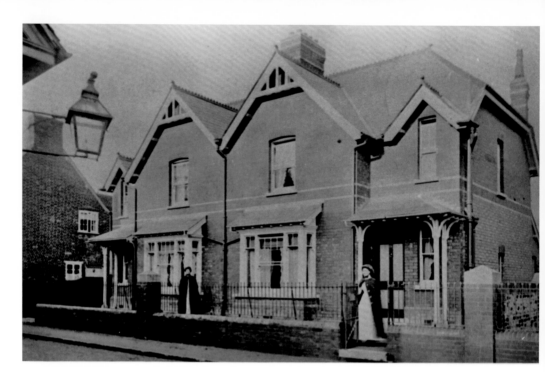

Bryanston Street

The nurses' home in Bryanston Street seen in the top photograph with nurses in what we would now consider impractical uniforms, is now two family homes. Rumour has it that a nurse was murdered here in the late 1800s. Although there is still a thriving hospital in Blandford, there is no longer a need for a dedicated residence for the staff.

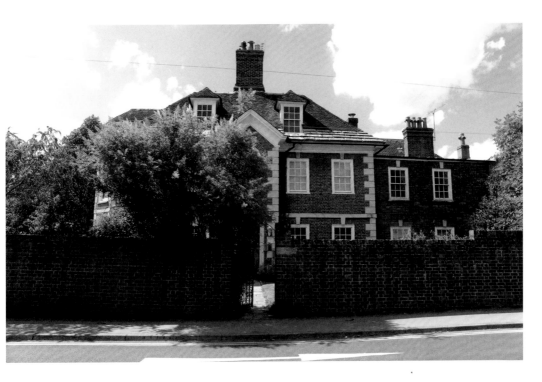

Dale House

The bulk of this building, Dale House, at the top of Salisbury Street, was built in 1684 and survived the 1731 fire. However the present front, shown in both photographs, has the distinctive brick and stonework that appears in many of the Bastards' houses. It now houses the Constitutional Club, the Con Club.

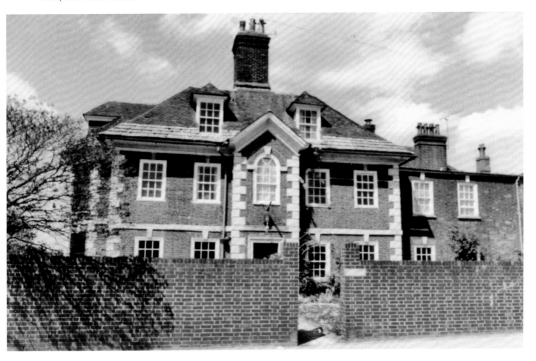

Coupar House

Coupar House in Church Lane was built by the Bastards after the 1731 fire, opposite Lime Tree House shown on page 30. It has housed, at separate times, the botanist Dr Richard Pultney and Francis James Stuart, 16th Earl of Moray and now is the headquarters of the Blandford Royal British Legion.

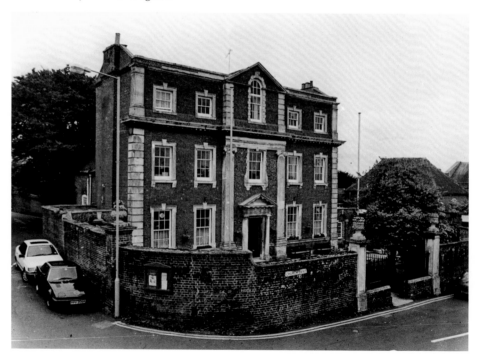

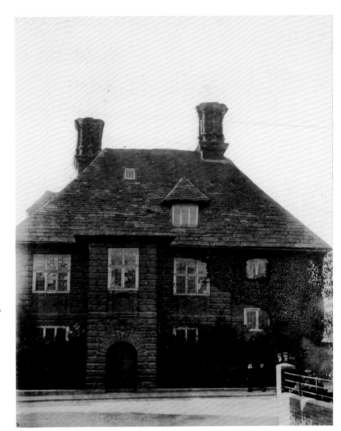

The Old House
The Old House is the oldest house still extant in Blandford, having survived the fire of 1731. It was supposedly built by three families of German refugees in the 1660s. It has changed hands several times, varying between one and several families living in it at any one time.

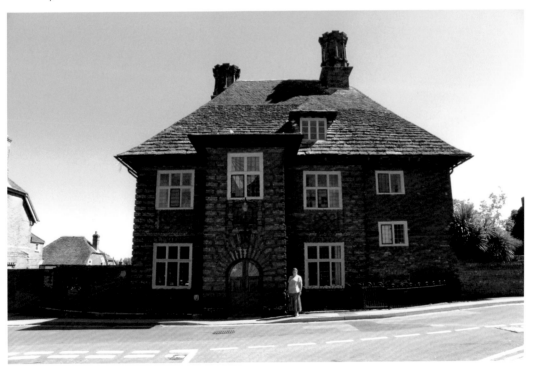

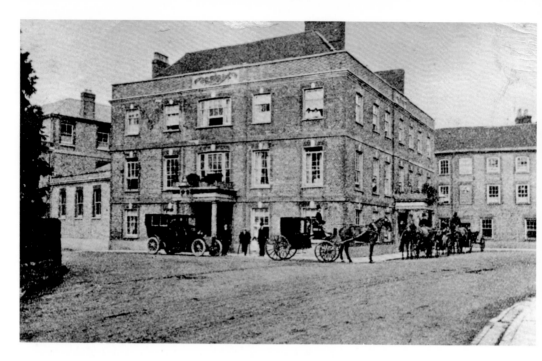

The Crown Hotel

The Crown Hotel, situated in West Street off the west end of the Market Place and now owned by the Hall and Woodhouse Brewery, was always a coaching inn. When the news of the victory at Trafalgar was posted from Falmouth to London in November 1805, this was Lieutenant John Richard Lapenotiere's twelfth post-horse change. He arrived here in the middle of the second day of the journey, 5 November, and he was charged £2 10s 6d.

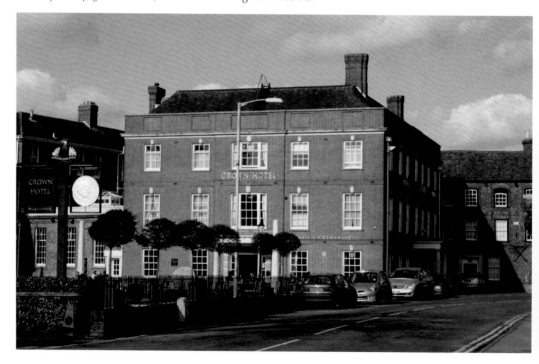

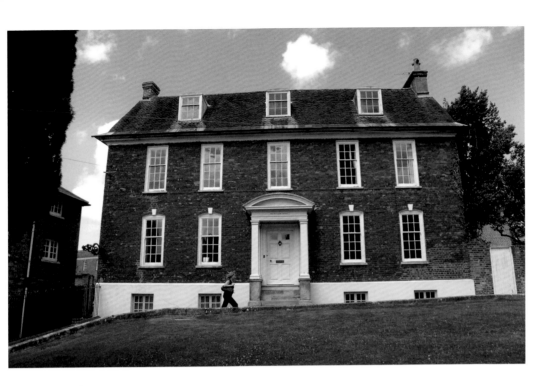

Old Bank House

This is the Old Bank House. The lower (white) ground floor is all that remained of the old grammar school after the 1731 fire. The school closed because it was in competition with the East Street School, which was very successful. The building was also used as the first savings bank in Blandford in the early Victorian period.

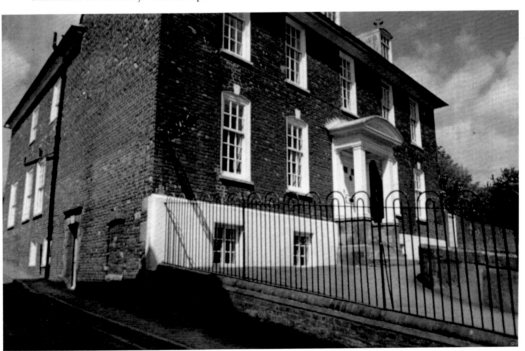

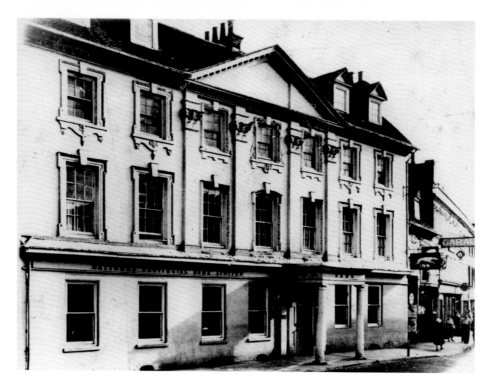

Greyhound House

The Greyhound was one of the three coaching inns in Blandford and its imposing façade dominates the west end of the Market Place. It has long been converted into offices, although there is still a Greyhound pub located behind it in what used to be the coaching yard and stables.

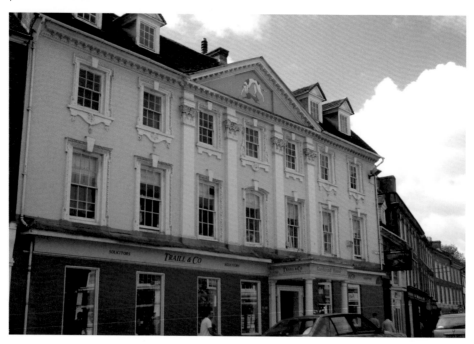

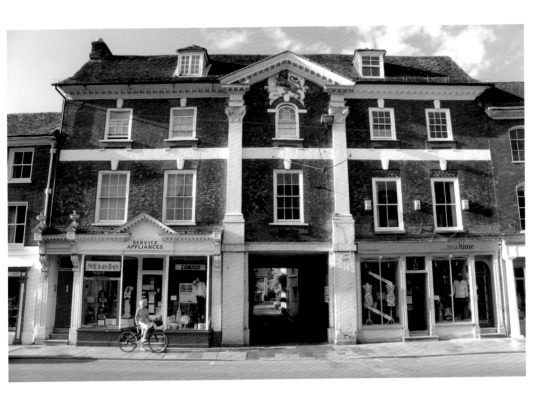

Red Lion House

Red Lion House, in the Market Place, in prime position directly opposite the Town Hall and Shambles was another coaching inn. The archway leads through to Red Lion Yard where the Red Lion pub was situated.

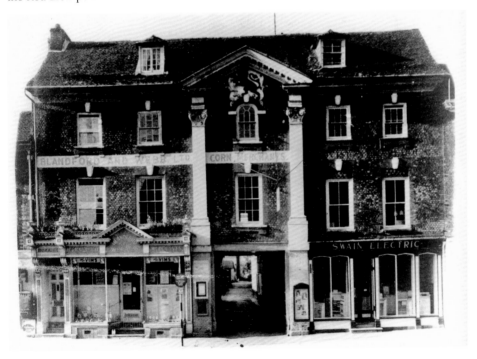

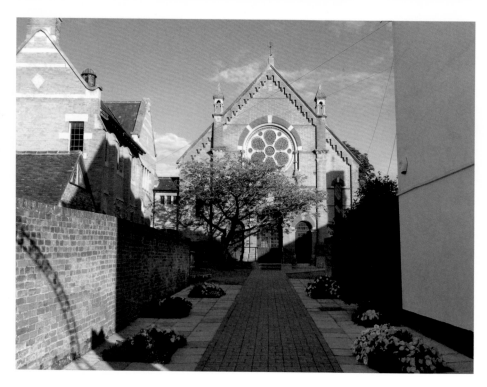

The United Reformed Church

The United Reformed Church in Salisbury Street was built in 1867. It replaced a Congregational Chapel which in turn replaced the meeting house for a congregation of dissenting Protestants that was destroyed in the 1731 fire.

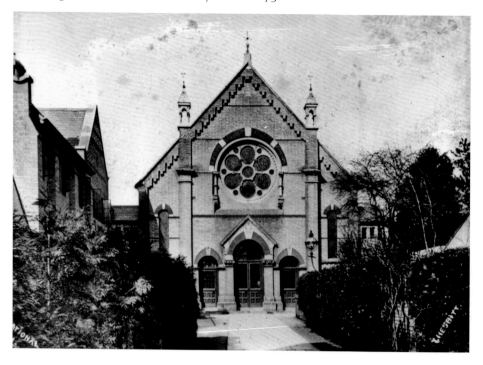

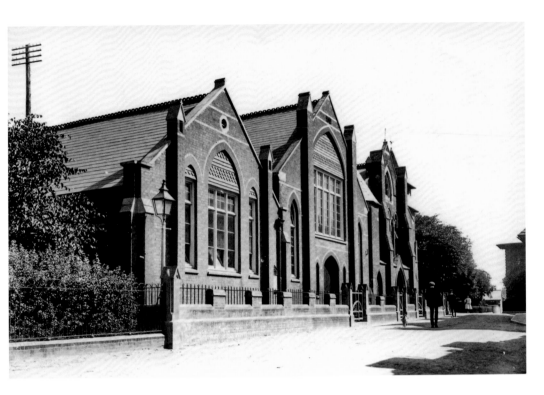

The Methodist Chapel

The Methodist Chapel is situated adjacent to the Tabernacle where for several years before the parish church was re-built, 'a tabernacle of boards was built for divine service north of the sheep market' (Hutchins p. 217) following the fire in 1731.

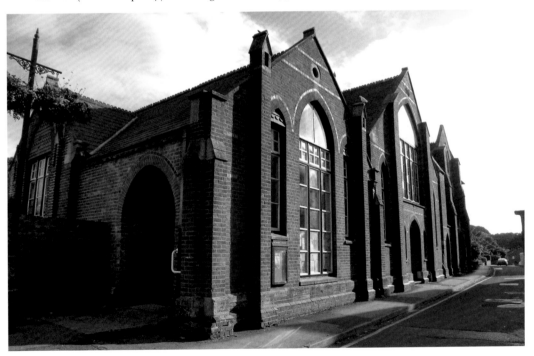

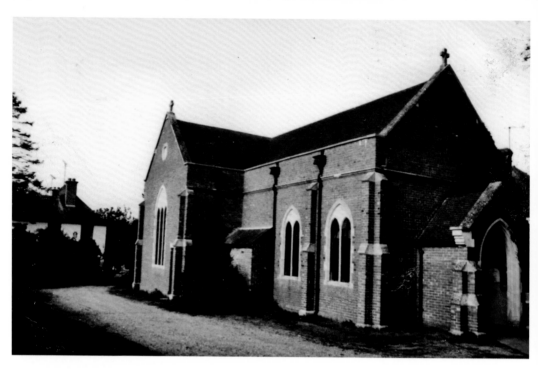

Church of Our Lady of Lourdes and Saint Cecilia
The foundation stone for the Roman Catholic Church of Our Lady of Lourdes and Saint Cecilia
was laid in 1934. While it was being built the Catholic priests lived in the Old House in the Close.
They now live in the presbytery that can be seen behind the church.

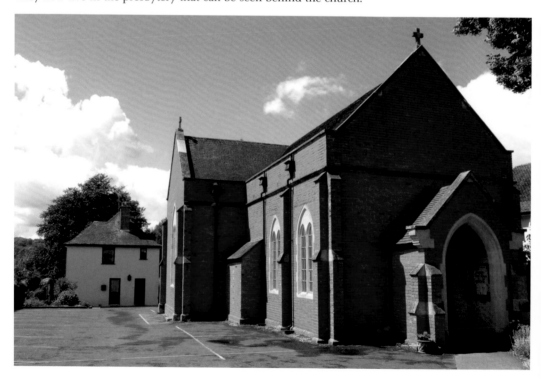

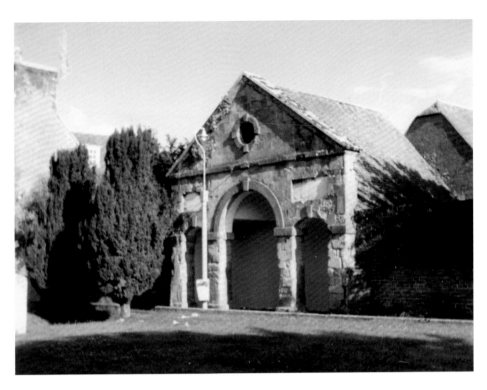

Old Bath House

What is known as the Old Bath House is all that is left of the almshouses that were located here behind the parish church. This building was last used as a bath house in the Second World War.

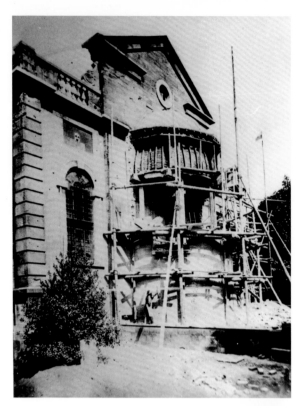

St Peter and St Paul's
These pictures are taken of the east
end of the parish church, St Peter and
St Paul's. The scaffolding in the older
photograph dates it to 1895 when
the apse was moved and the chancel
inserted. The end result can be seen
in the modern picture.

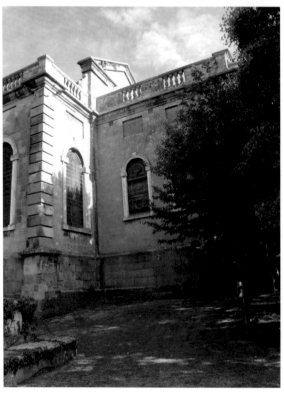

St Peter and St Paul's
These interior shots of the parish
church show the many changes
that have happened. The pulpit was
moved from left to right in 1874; the
original box pews were replaced with
shorted ones in 1883; the chancel
was inserted in 1895; and the side
galleries removed in 1971.

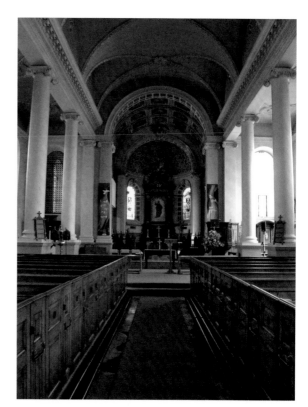

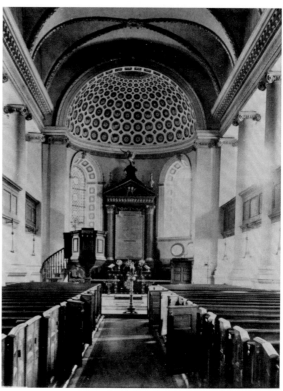

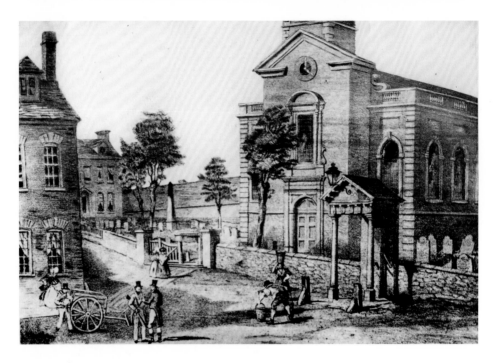

St Peter and St Paul's

The west end of the church faces into the Market Place. The drawing of this corner of the church and Market Place is included because it shows the incredible accuracy of the artist, the modern photograph looks almost the same; even The Bank House, the town's grammar school at the time, can be seen at the top of the cemetery behind the church. The engraving, 1825, shows the water pump erected as monument to remember the Fire and to thank God for a successful rebuild and the Church of St Peter and St. Paul. This is a reproduction of the earliest known engraving of the Church of St Peter and St Paul after its rebuilding in 1739. What is not shown is the top of the tower where, due to shortage of funds, a temporary cupola, that still remains, replaced the intended spire.

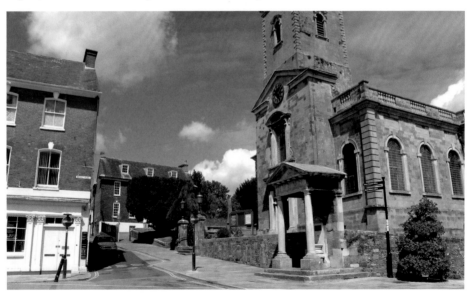

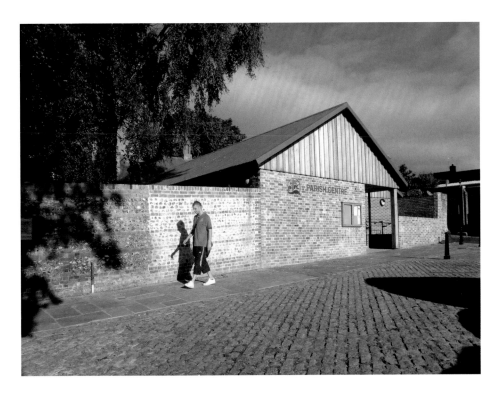

Parish Centre
The old Parish Rooms were erected in part of the Rectory garden by the then Rector, the
Reverend C. H. Fynes-Clinton. They were condemned because of asbestos in 2004. The new
and environmentally sound Parish Centre, shown above, was opened in February 2010.

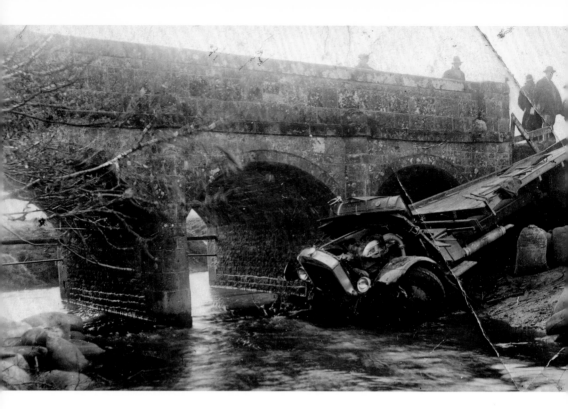

Big Lorries, Narrow Streets

We don't know why the lorry in the top photograph swerved as there is no corner! For the bottom photograph taken in 1985, there is a bigger swing round space now from the Market Place into Salisbury Street, so it should be impossible to get a lorry jammed in this fashion today.

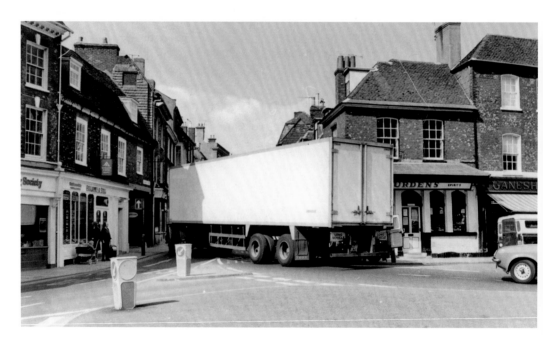

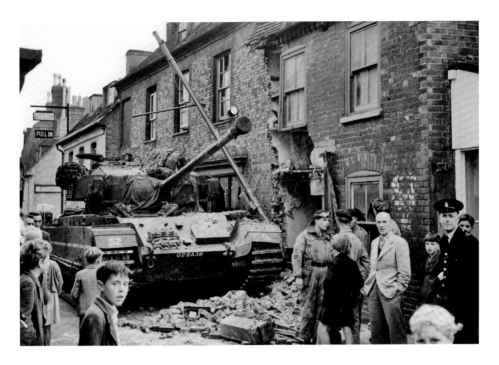

Big Lorries, Narrow Streets

There are no obvious marks today of the crash shown in the bottom photograph. The house that this tank crashed into in Whitecliff Mill Street in 1951 is still there and looks unscathed. Although tanks no longer go through the town, we still get increasingly large lorries making their way through some of the narrow side streets, sometimes with great difficulty.

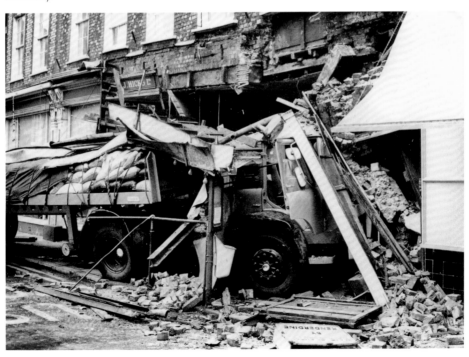

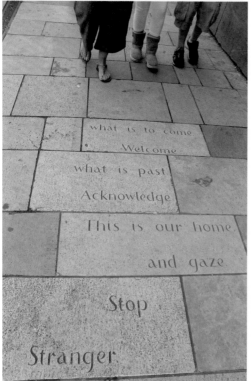

what is to come
Welcome
what is past
Acknowledge
This is our home
and gaze
Stop
Stranger

Pavements

The top photograph shows damage that was obviously causing concern in the 1970s. The bottom photograph shows one of the set of engraved words that were placed around the Market Place when it was refurbished in 2000. In the 1980s one of the pavements in West Street broke revealing a brick tunnel two feet wide and six feet deep.

Sheepmarket Hill

Sheepmarket Hill runs from the Tabernacle down to East Street. The livestock markets moved here from the Market Place in the 1820s. They then moved to The Fairfield on Salisbury Road, see page 21, and stopped in the 1940s. Today Sheepmarket Hill is the site of handy town centre parking.

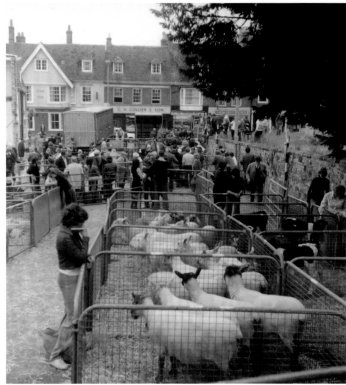

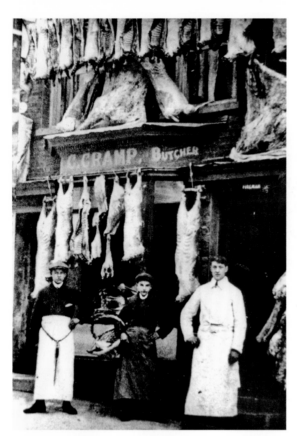

Butchers

Over the years Blandford has had many butchers, at the moment we have two. Charles George Clamp was a butcher in Salisbury Street between approximately 1911 and 1925. No modern butcher would be allowed to display his wares like this. As can be seen from the bottom photograph, it is now an estate agent.

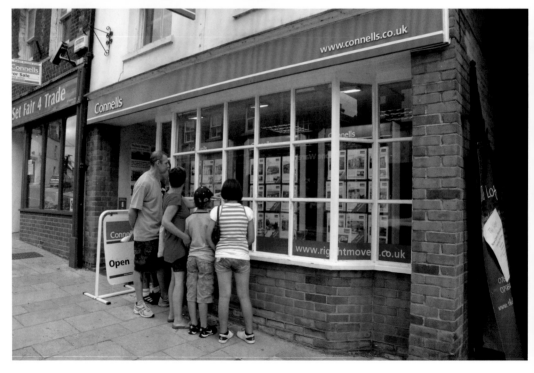

Watchmaker

Several generations of the Westcott family ran a watchmaker and jewellery store in the Market Place. Since then the shop front has been heavily changed as can be seen in the top photograph of the existing shop.

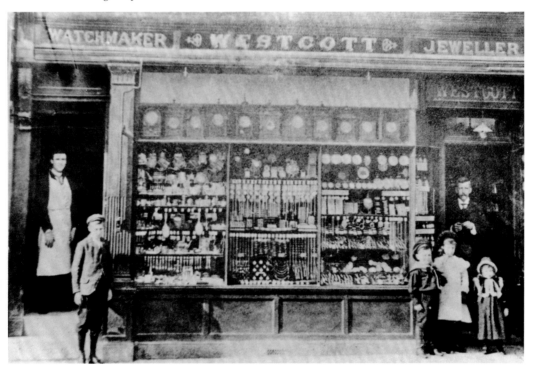

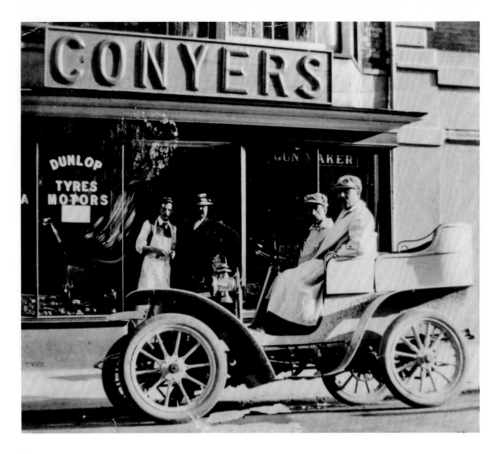

Conyers

Arthur Conyers opened a garage and motor parts shop in West Street in the 1920s. This is now a shop selling fishing and shooting paraphernalia, having been a radio store during the interim. Not only the name remains but entering the shop is like stepping back in time, with features such as the original wood floors still in existence.

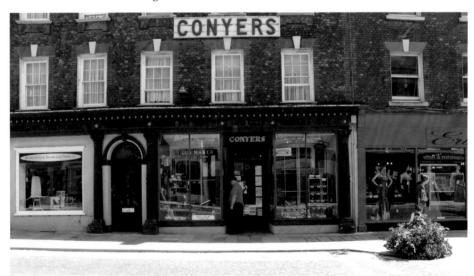

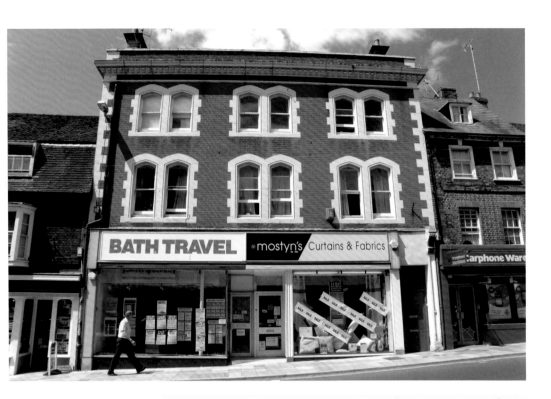

Grocers

The Stores on Salisbury Street were in fact Wareham and Arscott, grocer. They are shown here decorated in celebration of George VII's coronation in 1910. The building is now divided into two businesses (a travel agent and a soft furnishings shop) and the shop front has been changed, but the building above the shops is instantly recognisable.

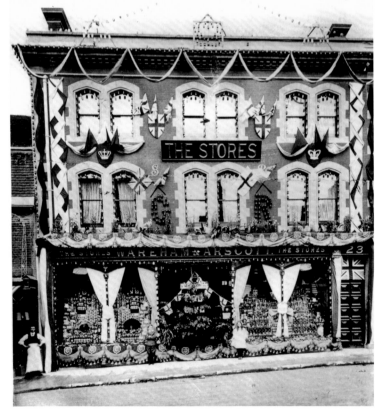

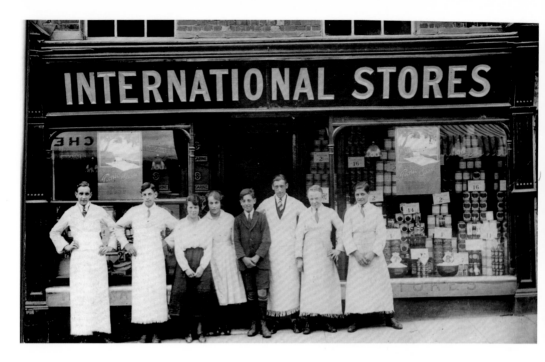

International Stores

International Stores were owned by the International Tea Company and without a list of shops and their owners compiled from directories such as Kellys, it would have been almost impossible to recognise as the building as that houses the present day opticians.

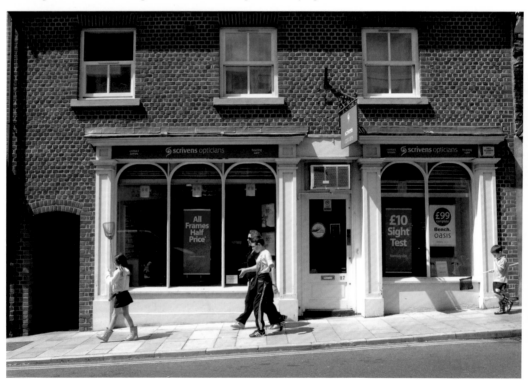

Boot Maker

It is much easier to match up these two photographs; simply look at the surround of the glass fronts. Henry Blandford had been a boot and shoe maker in this shop since the early 1900s, and as can be seen, hand-sewn work was a speciality.

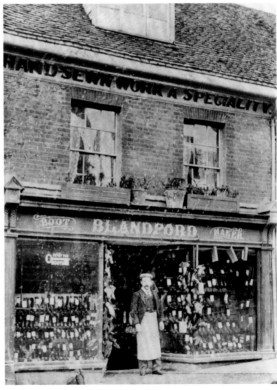

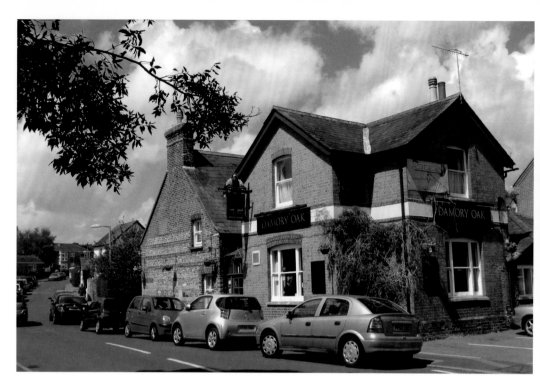

Damory Oak Pub

Damory Oak pub is situated just off the Wimborne Road. It used to be dwarfed by the embankment, on the left, for the Somerset and Dorset Railway, but that has been removed and it now faces a row of houses.

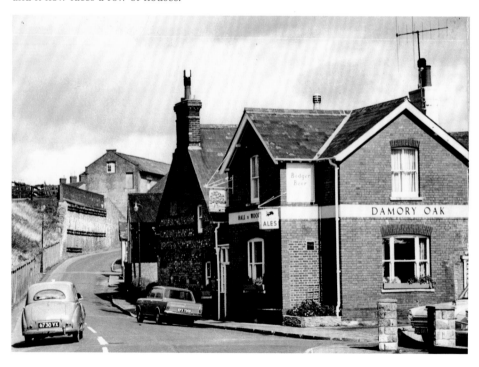

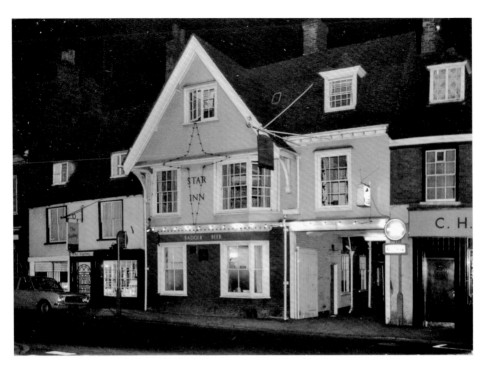

Star Inn

Star Inn in East Street opposite the bottom of Sheepmarket Hill is no longer a pub but a shop. Although the name has changed to signify this difference, the old sign hanger still remains above the alleyway leading to the Rugby Club.

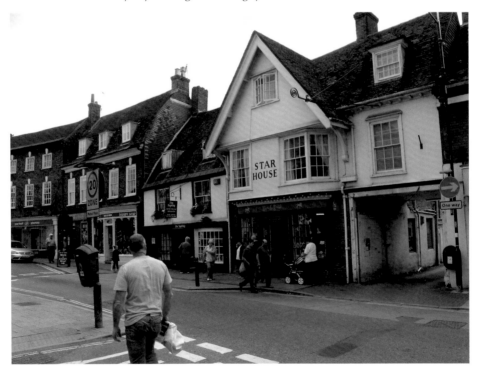

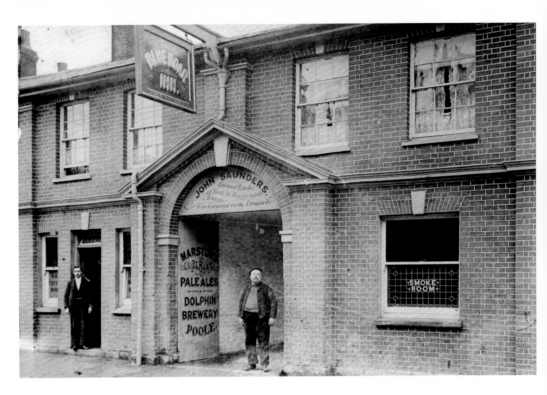

Blue Boar

As can be seen from the bottom photograph there is no sign remaining of the Blue Boar Inn which was situated at 10 East Street. It was built in about 1900 for the Dolphin Brewery in Poole.

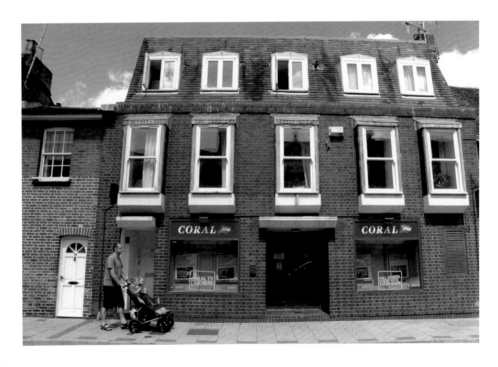

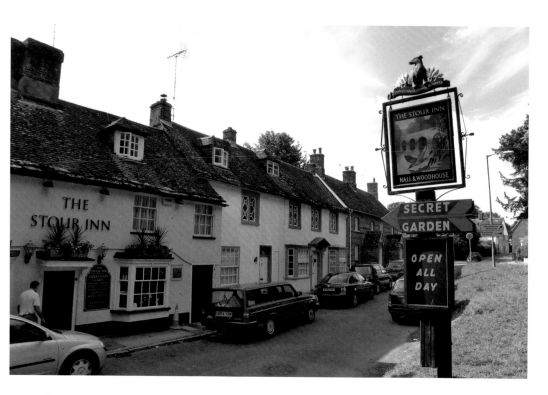

The New Inn

The New Inn, now called The Stour Inn, is actually over the bridge and in Blandford St Mary, but it has been included as it is still very recognisable. It also still belongs to the Hall & Woodhouse brewery.

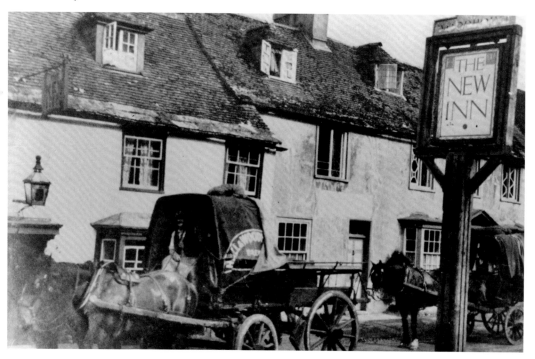

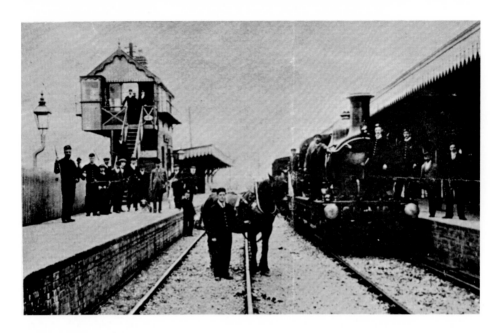

Blandford Forum Station

The top photograph shows Blandford Forum Station with all the staff lined up and with a shunting horse. As the name implies these horses were used for moving wagons around the yard. There must have been several at Blandford as the stables provided were spacious. The bottom photograph is of an exact scale replica model of the station which has been made by the members of the Railway Club based at Blandford Forum Museum. This has taken three years to build so far, in 2010, and the work is still on-going. Each detail is painstakingly checked against old photographs.

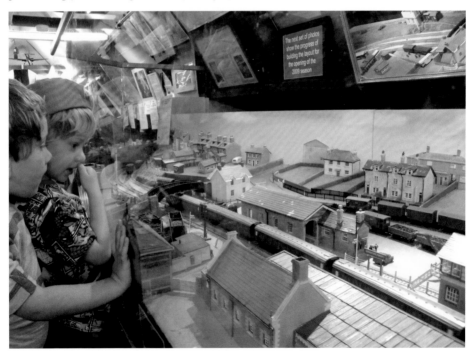

Railway

The top photograph shows almost exactly where the train is standing in the bottom photograph. The station was demolished, along with a lot of the rest of the railway, in 1978 when Dr Beeching closed so many local lines and stations. Much remains including a sunken trail used by walkers, the Stationmaster's house, street names and one arch of the brick bridge that used to cross the River Stour.

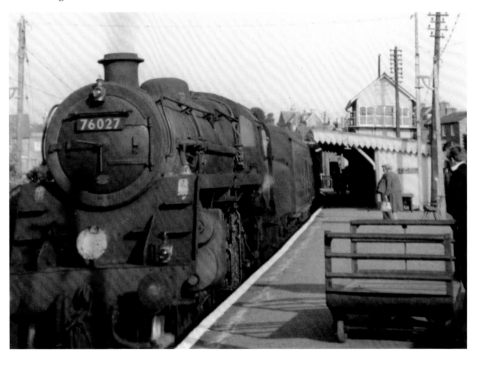

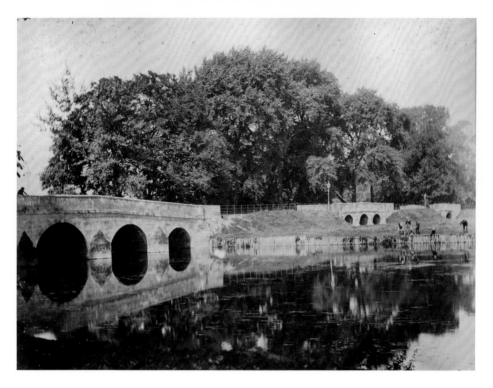

Bridges

Of the three bridges into Blandford from Bryanston shown in the top photograph, the first one is the road bridge over the River Stour and the other two are to allow passage over the flood waters. It is impossible now, due to building and vegetation, to replicate this view. However it is possible to get a reverse view from the other side of the bridge, from Blandford looking towards Bryanston as is shown in the bottom photograph.

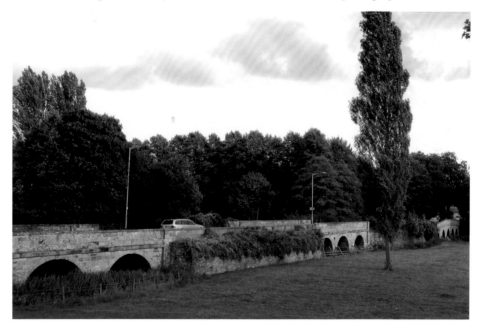

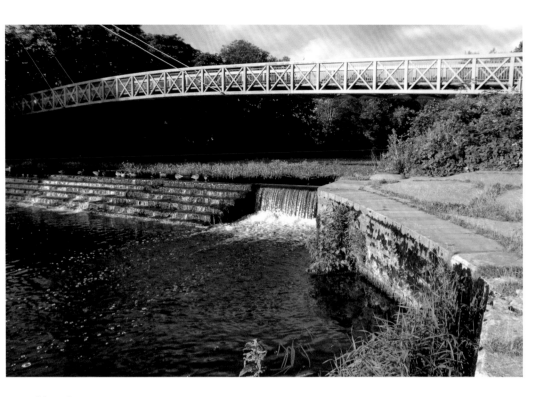

River Stour

The weir on the River Stour remains the same. However the view of the opposite bank has been obscured by vegetation and the weir is now spanned by the Mortain Bridge. The weir still occasionally claims the lives of people who are not aware of its power.

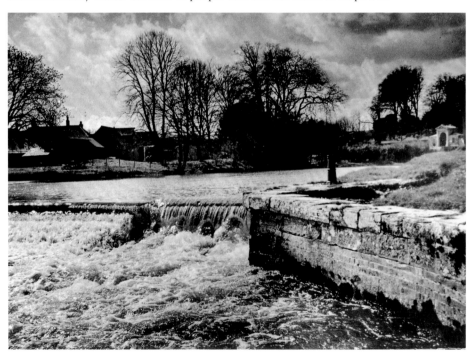

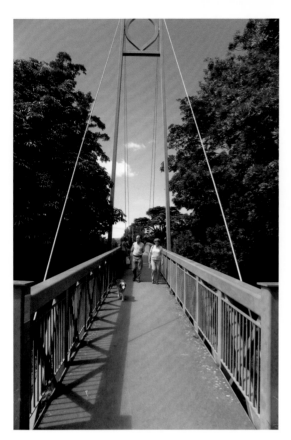

Bridges

There are now two new pedestrian bridges over the River Stour. Both named for the towns with whom Blandford is twinned. The top photograph shows the Mortain or Blue Bridge, which crosses to the open space called Stour Meadows from the west end of town. The bottom photograph shows the Preetz or Black Bridge, which runs from the east end of town to Stour Meadows. The latter is strongly reminiscent of the traditional railway bridges as its location is close to the point that the trains crossed the River Stour.

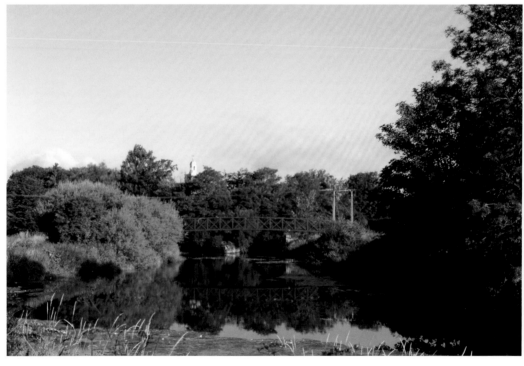

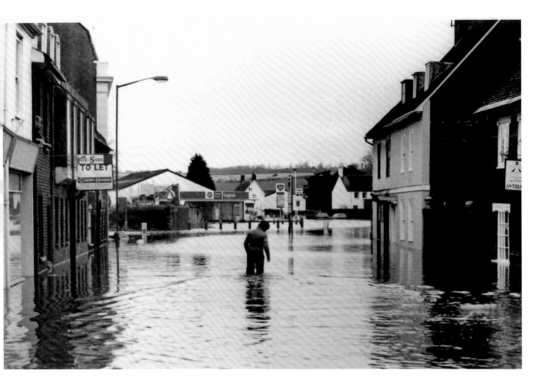

Floods and Flood Defences

In the past, the River Stour had a tendency to flood Blandford. The top picture was taken at the east end of East Street in 1979. However since the building of the flood defences in 1995 the town has remained unflooded. The bottom photograph shows part of the defences in the Ham and Marsh car park, where there is a gap in the defence wall to let cars through which can be closed when a flood is threatened.

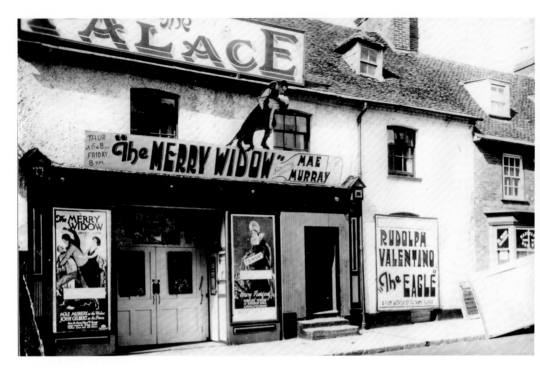

Palace Theatre

The top picture shows the Palace Theatre, the first cinema in Blandford, which was built prior to the First World War on the north side of East Street. It closed after the war due to lack of demand. However increased demand in the Second World War caused it to be re-opened as The Ritz. It closed in 1957. The site is now a row of modern buildings.

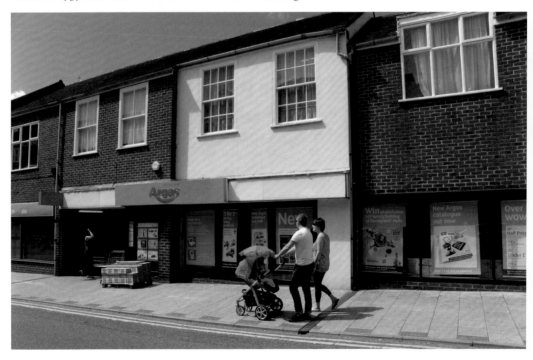

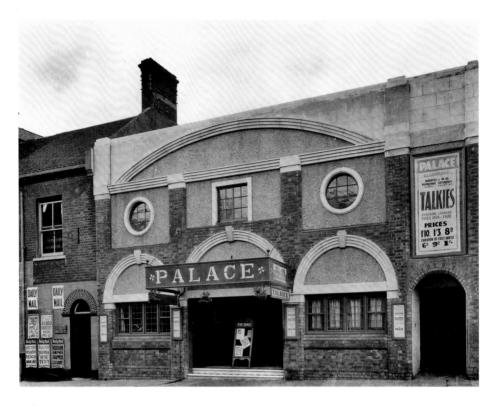

Palace Cinema

The Palace Cinema, shown in the top photograph, was built just before the Second World War on the opposite side of East Street from the old Palace/Ritz. Its façade was changed during the 1960s as can be seen in the bottom photograph.

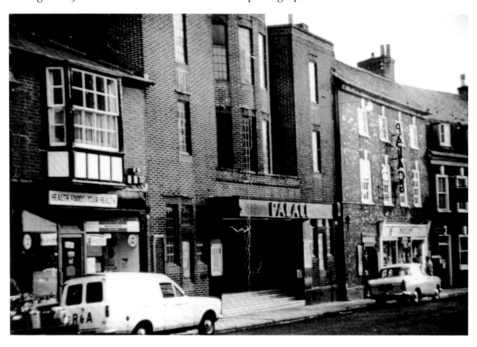

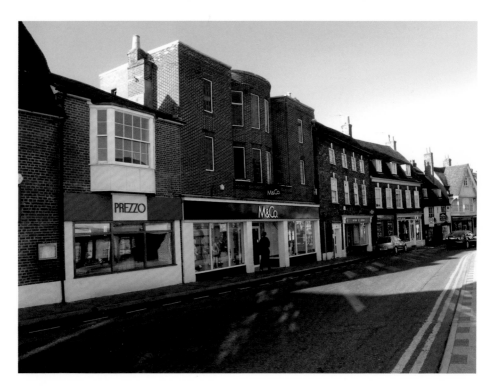

Cinemas

Unfortunately The Palace Cinema closed in 1971, although its distinctive façade can be seen above the present day shop front in the top photograph. The bottom photograph shows its interior during its heyday.

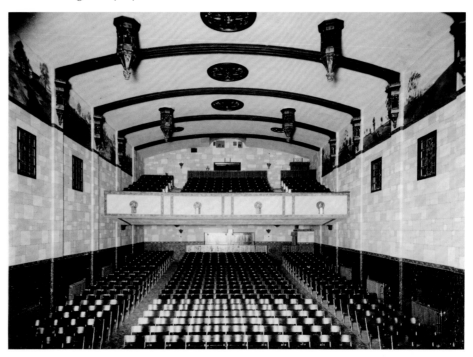

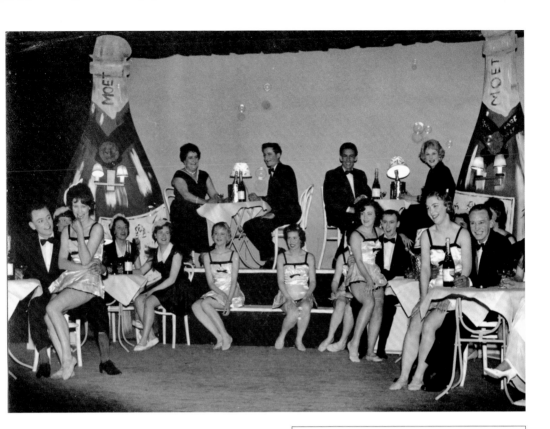

Amateur Dramatics

Here we see the Footlight Follies in a promotional photograph for one of their productions and one of their flyers. After a gap of several years there is now an amateur dramatic troupe, Blandford Amateur Dramatic or BAD Productions, in Blandford again.

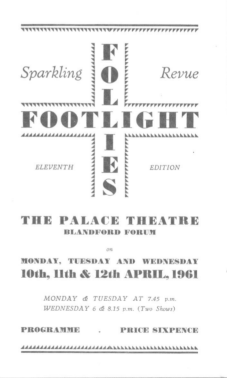

Sparkling *Revue*

FOOTLIGHT
FOLLIES

ELEVENTH EDITION

THE PALACE THEATRE
BLANDFORD FORUM

on

MONDAY, TUESDAY AND WEDNESDAY
10th, 11th & 12th APRIL, 1961

MONDAY & TUESDAY AT 7.45 p.m.
WEDNESDAY 6 & 8.15 p.m. (Two Shows)

PROGRAMME . PRICE SIXPENCE

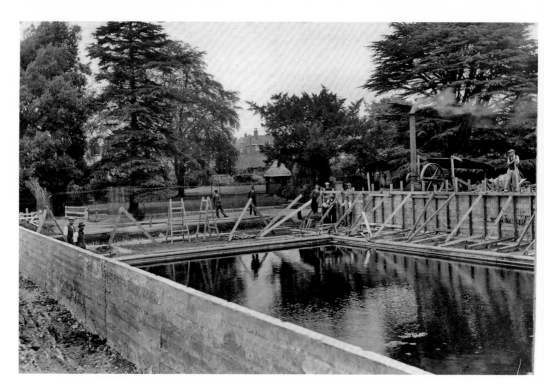

Swimming Pool

In 1924 an open-air public swimming pool was built down near the River Stour, where there is now a large car park. The money was left by John Iles Barnes, a local Victorian philanthropist, in his will in 1913. It was closed in 1993. Nowadays Blandford is served by the pool in the Leisure Centre attached to the Blandford School shown in the bottom photograph.

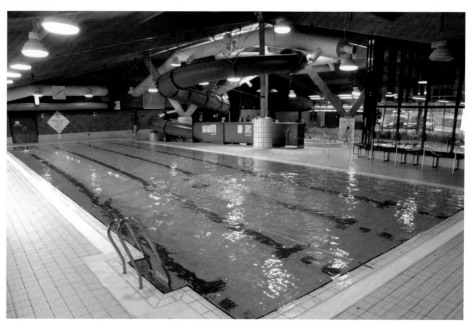

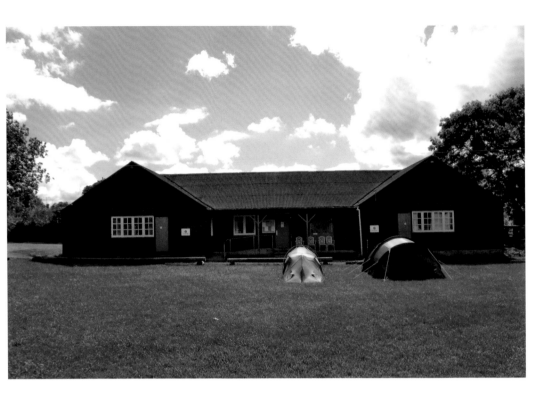

Scout Hut

Tucked away on the edge of town and therefore surrounded by green fields is the Scout Hut built in 1936, home to the Blandford Scout Group. It was used by the Home Guard as their headquarters during the Second World War. As can be seen from the photographs it has not changed in the last thirty years since the bottom photograph was taken.

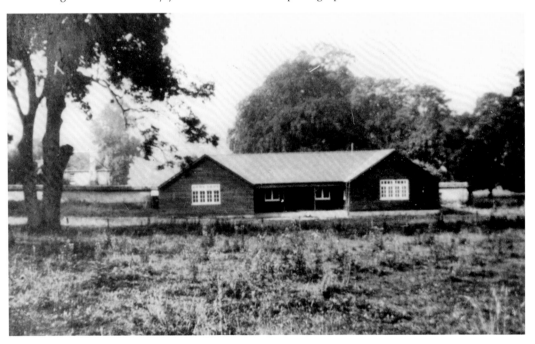

Milldown School

The bottom photograph is a picture of a private school possibly run by a Mr John Trickett. He later moved the school up to the north of the town. At this location it then became Milldown First School, and then later Milldown Primary School and as this school is now closed, it is the entrance to the school property which is shown in the top picture.

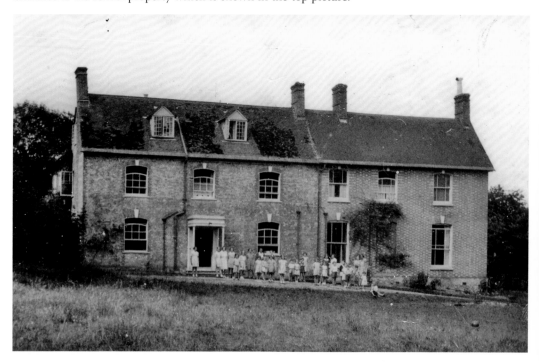

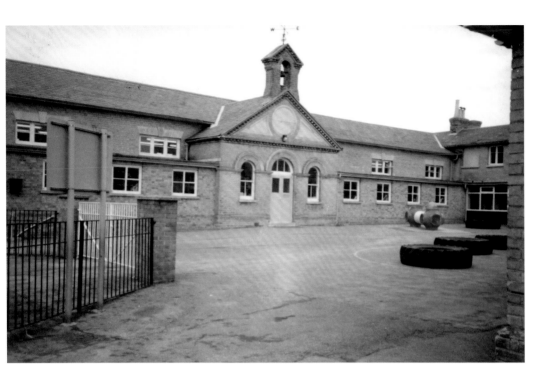

Blandford Boys' School
The top photograph shows the Victorian building which was the Blandford Boys' School. It was extended over the years and became Archbishop Wake School, named after the Blandford-born Archbishop of Canterbury who left money to endow a school for boys. The bottom photograph shows what is there now as the school moved out in 2008.

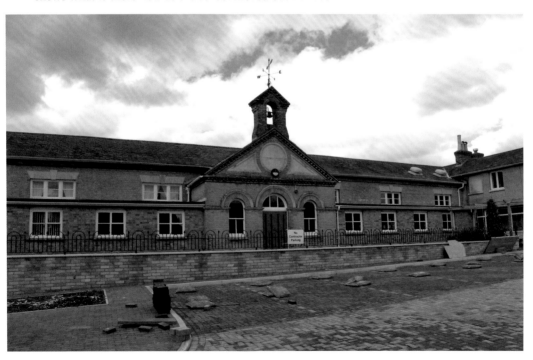

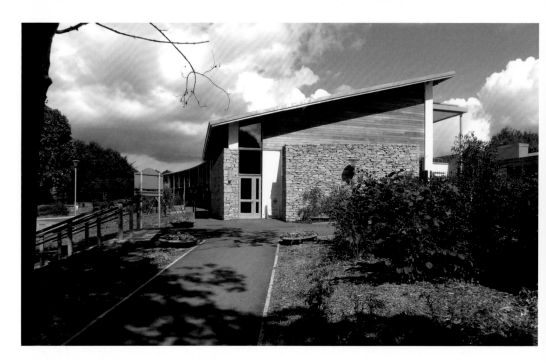

Schools

These two pictures show the new primary schools that have been built in Blandford following the re-organisation of the school provision in 2006. The top one shows Archbishop Wake Primary School which was opened in 2008; the bottom one shows Milldown Primary School, opened in 2010. Close inspection of the latter photograph shows, on the left side, the Milldown Middle School which is about to be demolished.

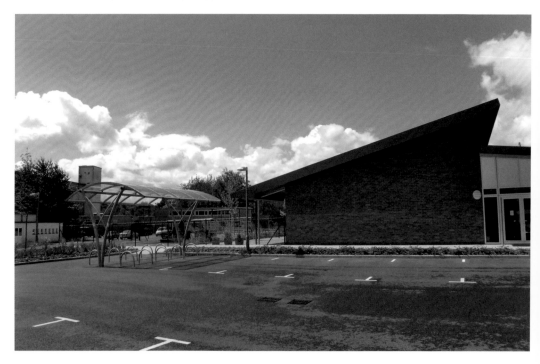

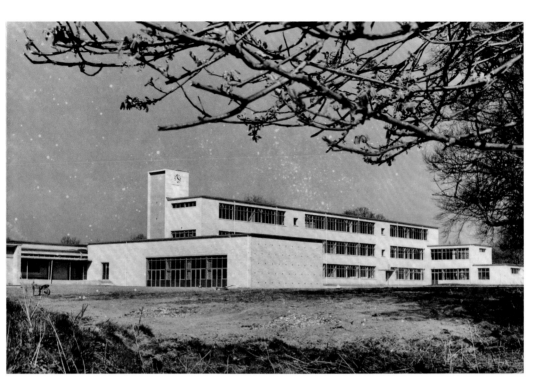

Schools

The top picture shows the secondary modern school which became Milldown Middle School, seen on the previous page. The bottom photograph shows the front of the Blandford School which was built on the same campus.

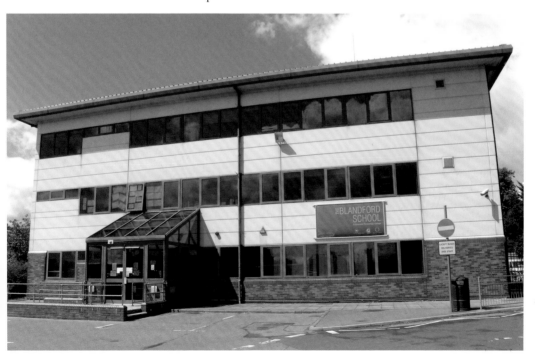

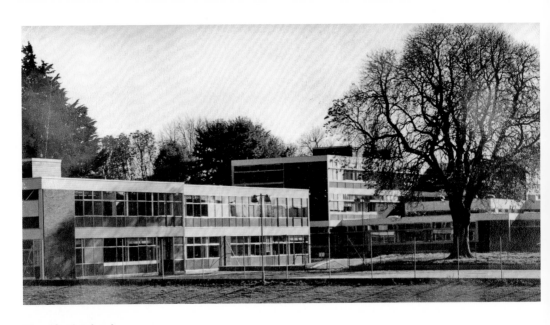

Blandford School

These two photographs show the back of Blandford School. It was known as the Blandford Upper School until 2006 and is going through a planned programme of building works.

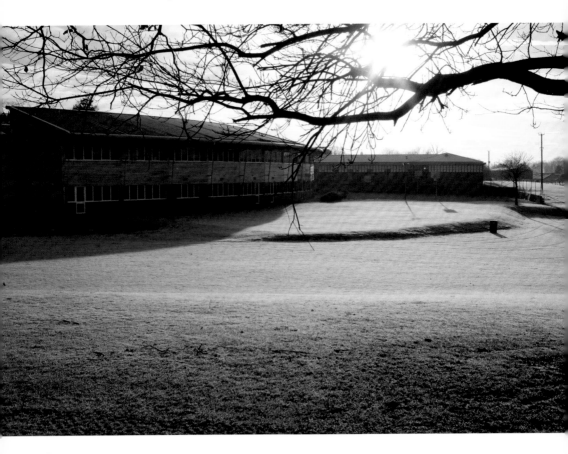

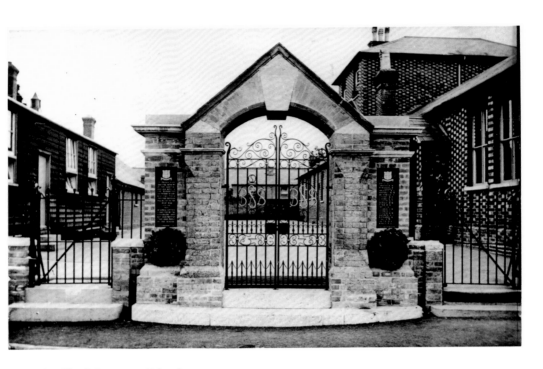

Blandford Grammar School

All that remains of Blandford Secondary School in Damory Street, which became the Blandford Grammar School, is the gateway. The buildings have been demolished for housing and the memorials on the gates have been moved to the Blandford School.

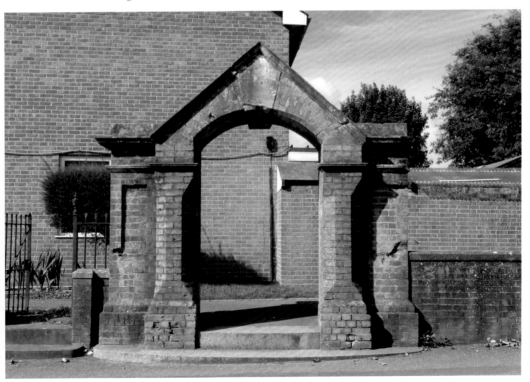

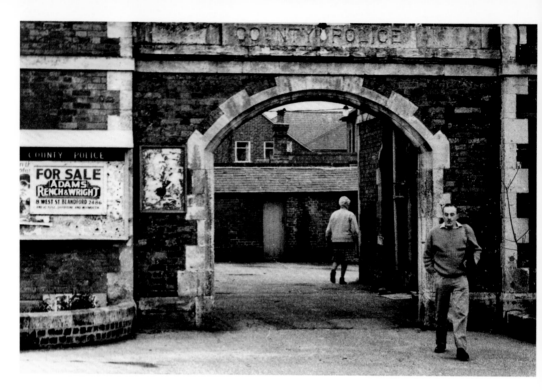

Police Station

This fine archway in Salisbury Road used to admit one into the old Police Station. At one time the Police Station was located on Sheepmarket Hill. However, people now live here where the criminals used to be locked up.

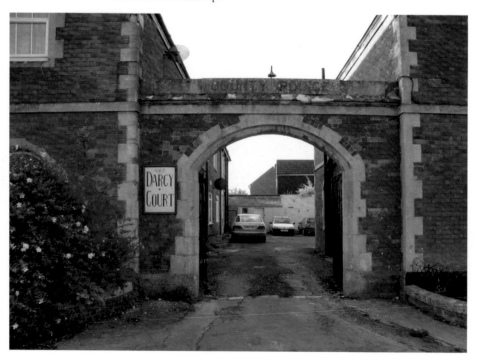

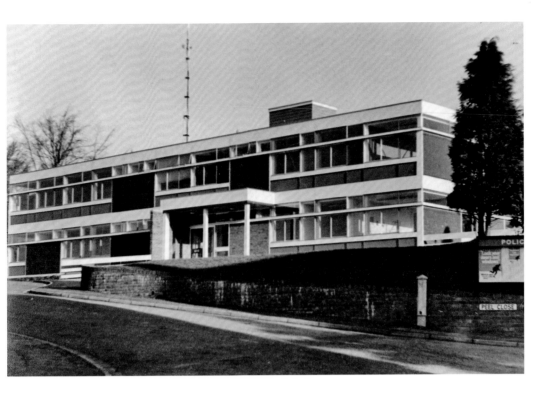

Police Station
The Police Station moved up Salisbury Road, further out from the centre of town. The first photograph was taken in 1969 and the station has either had a face lift or has been rebuilt since. Also noteworthy is the growth of the tree to the right of the photographs.

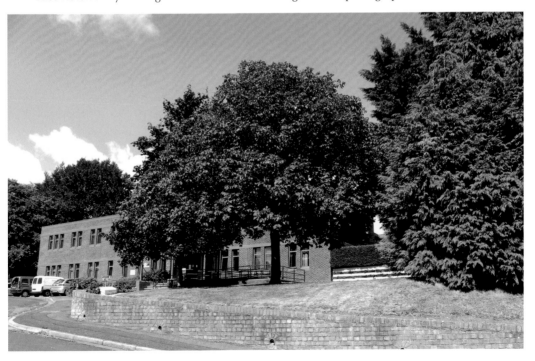

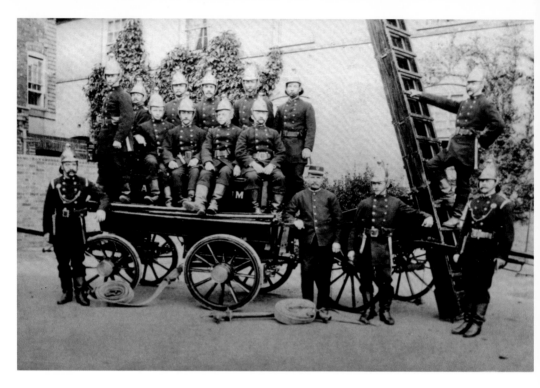

Fire Service

The firemen in the top photograph are the Borough Brigade of 1900. They are photographed in Greyhound Yard where it is assumed that they stabled the horse that would have been used to pull their wagon. The bottom photograph is from the 1920s and shows the members of the brigade in mufti standing by their motorised vehicle.

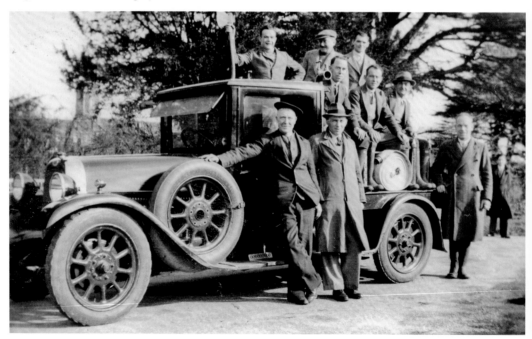

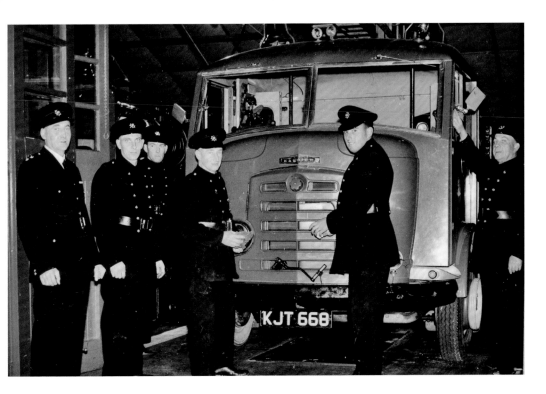

Fire Service

The top photograph, taken in the 1960s, shows a recognisable fire engine and some of the crew in uniform. The final photograph was taken in 2008 and shows the Blandford firemen with their two engines. They are a retained force, that is they are not full time; they have other jobs and come out on call when needed.

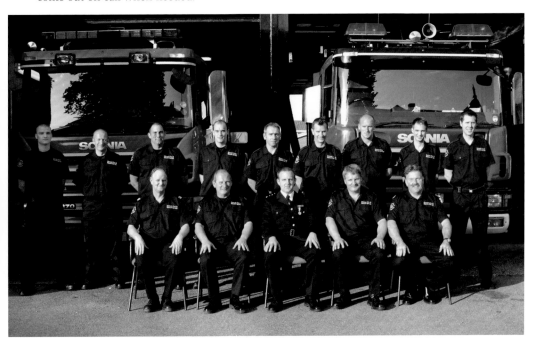

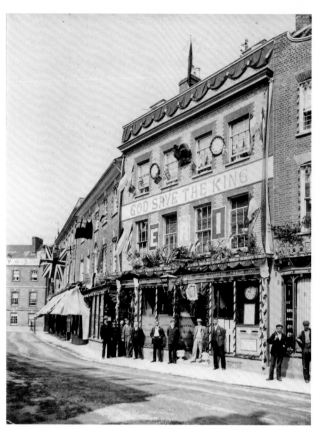

Post Office

The top photograph shows the old Post Office in West Street when it has been decorated for the Tercentenary celebrations in 1906. The bottom one shows G. Coats' carnival float, *c.* 1890, in front of Coats Farm which would become the new post office in the Tabernacle.

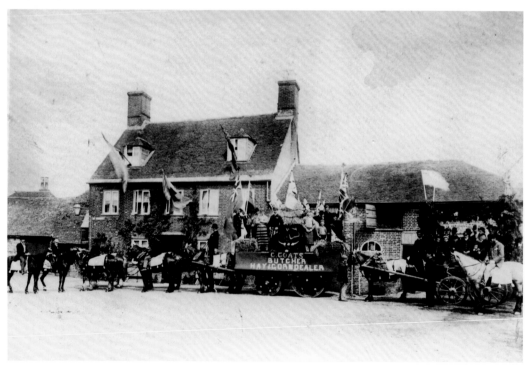

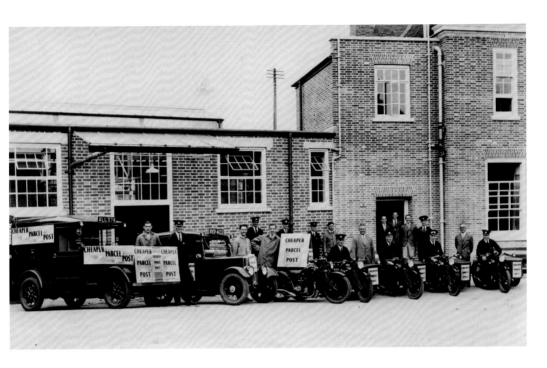

Post Office

The photograph of the staff and vehicles at Blandford Post Office taken in 1938 is taken at the side of the existing post office, the front of which is shown in the bottom photograph which shows a few of the current employees. The advertising does not seem to have changed much, even if the vehicles and the uniforms have.

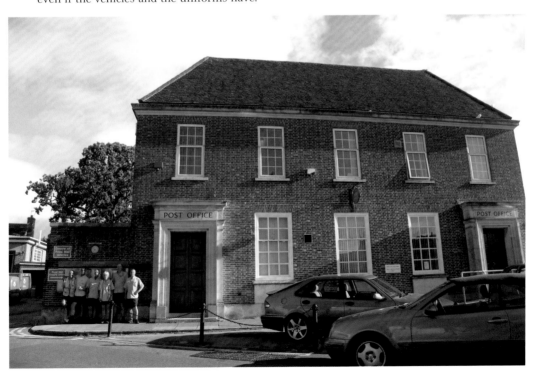

Markets

There is now a Farmers' Market in Blandford on the second Friday of every month, and it is this that is shown in the top photograph. There are also markets on every Thursday and Saturday and it is one of these, from the 1960s, that is shown in the bottom picture.

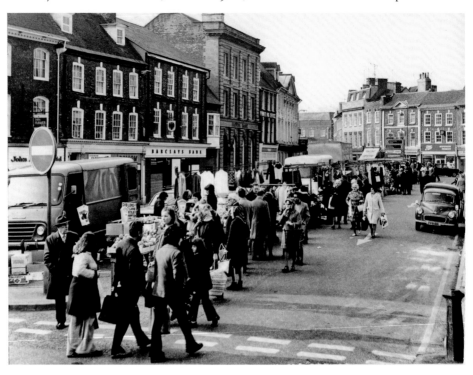

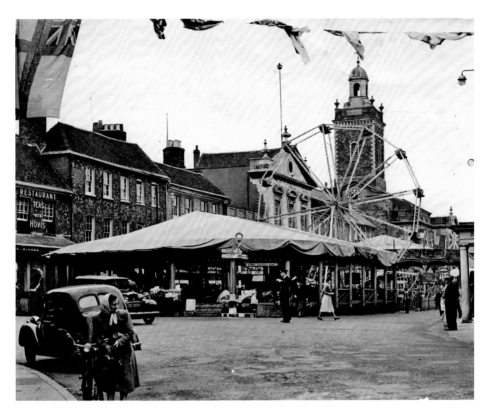

Carnival and Georgian Fayre

Blandford has long held funfairs in the Market Place as seen in the top picture of a 1950s carnival. The modern equivalent is the biennial Georgian Fayre shown below.

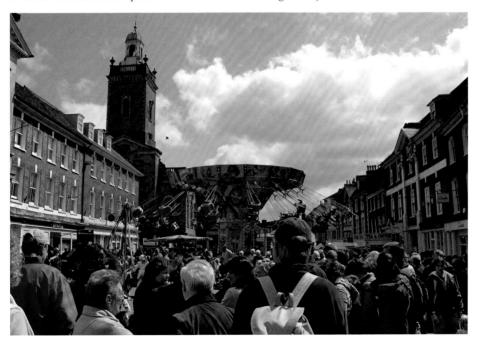

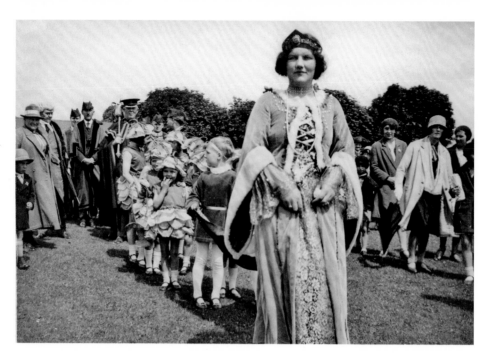

Carnival

Miss Mary Phelps who was Carnival Queen in 1931 can be compared with the 2009 carnival's Miss Teenager, Junior Princess and their two attendants who are being interviewed here by Katy Tomes, who with her sister Anna the photographer, were part of the Blandford Museum's Saturday Club entry.

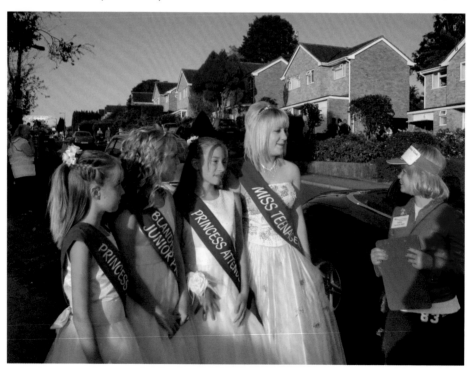

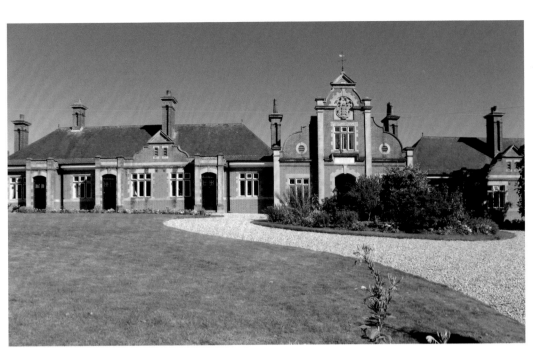

Barnes Homes

The bottom picture celebrates the handing over of the lease in January 1910 of the Barnes Homes. These seven almshouses were built by John Iles Barnes in memory of his brother Philip Abraham. The top picture shows them as they now are. What are not visible are the eighteen new almshouses that have since been added.

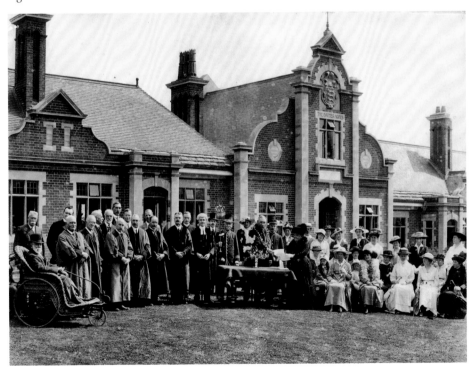

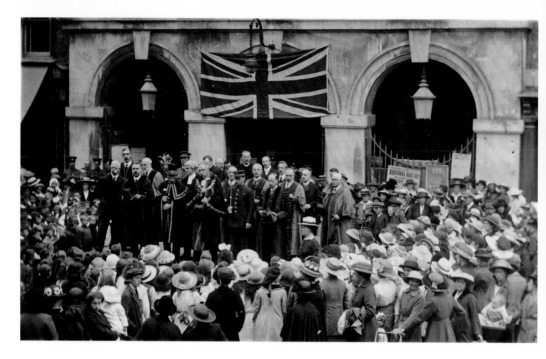

Civic Ceremonies

These two photographs show two of the many civic ceremonies and occasions that have occurred over the years. The top one shows the Mayor J. J. Lamperd in 1918 waiting to welcome home Private Jack Counter on his return from London where he had been presented with his VC. The bottom one shows the Mayor Esme Butler watching the Queen's Gurkha Signals as they marched past on 11 September 2005 when they were granted the Freedom of the Town.

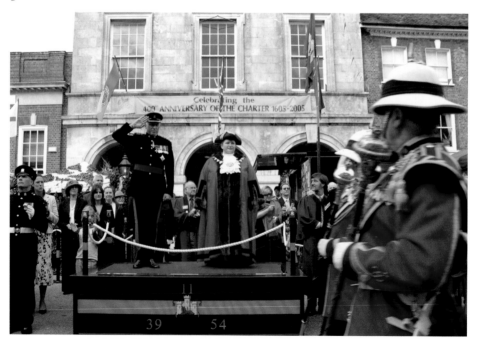

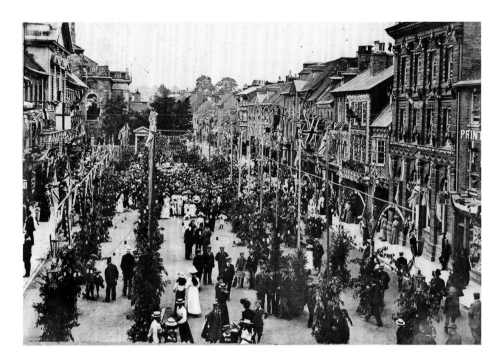

Tercentenary in 1905

These two photographs show the same scene in the day and at night. These were the decorations erected to celebrate the Tercentenary of the granting of the charter to the borough by James I in 1605. There were processions, bands played and the town was decorated in flags of crimson and orange, which remain the town's colours to this day. Over and above the arches built in the Market Place was one in East Street made to look like old fortifications.

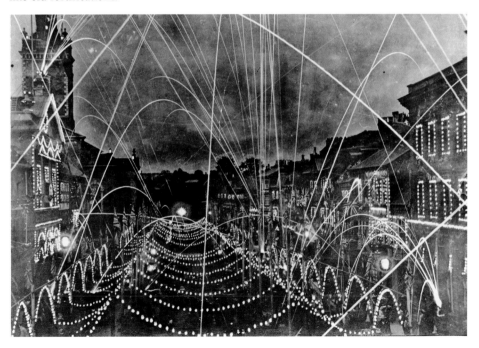

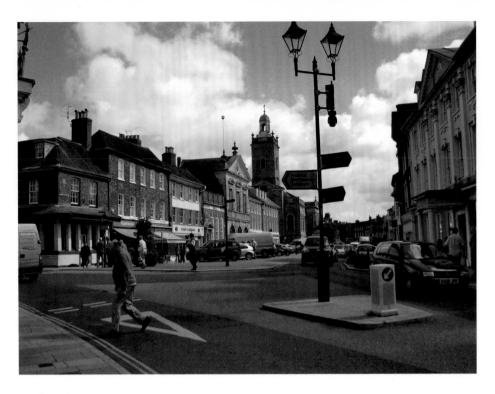

Market Place

Except for the changes that derive from the use of the car, these two pictures demonstrate how little the Market Place in Blandford has changed in over a hundred years. This has been a source of surprising satisfaction and an increased appreciation for the work of conservationists to the authors.

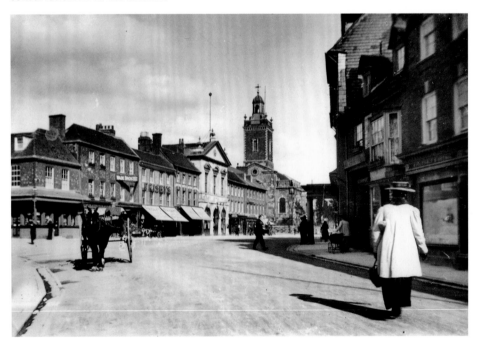

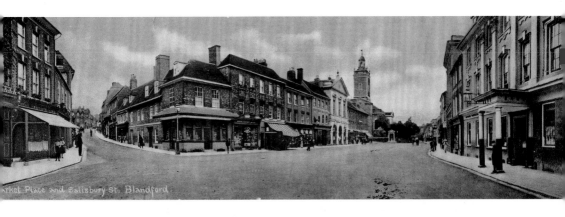

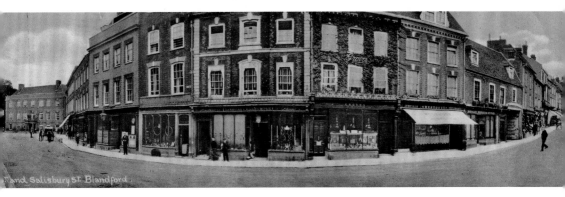

Panoramas

The two panoramic postcards above can be compared by a recent panoramic view of the town painted by a local artist, Jake Winkle, for the Town Council who have hung a copy in the Old Bath House, shown on page 45. What is abundantly clear is how little the fundamental architecture of this unique Georgian town has changed over the years.

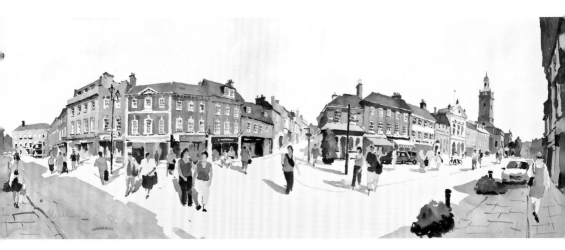

Acknowledgements

We would like to thank the Blandford Town Museum for access to their collections and for the use of their facilities. There are two Blandford historians who need mention for their research on Blandford Forum: Terrance Sackett and Ben Cox. Ben Cox was the founding curator and is now the Emeritus Curator of the Blandford Museum. His extensive research over the years produced many volumes about Blandford and this body of work contains almost all that is known of Blandford's past. We would also like to thank Pam Le Bas, the Museum Archivist who sadly died early this year, but whose efforts made researching this book a relatively easy task. One particular handwritten record by Victor Adams was vastly interesting and very useful as it documented how the buildings in the centre of town have changed hands and purposes through time. Bill Lovell maintains the photograph archives at the Museum and his organisation of the collection also facilitated our work. Finally many thanks to Michael Le Bas, who took time to answer questions, provide material and double check our facts!

The old photographs used in this book, with few exceptions come from the Museum Archive. Archival photographs are often not credited, but many of the photographs from the '50s through the '90s came from Sam Jardine, who generously donated his photographs to the museum. The modern photographs were supplied by us, with a few exceptions which were supplied by Adrian Oliver, David Crompton, Anna Tomes, Philip Ledwith, Jane Norman, Chloe Hixson, Rachael Harding and The Blandford School. Blandford Forum Town Council were exceedingly helpful and thanks goes to them and Jake Winkle for allowing us to include his panoramic view of the town.